INSTANT

ART
HISTORY

INSTANT

ART HISTORY

FROM CAVE ART TO POP ART

BY WALTER ROBINSON

A Byron Preiss Book

FAWCETT BOOKS • NEW YORK

A Fawcett Book
Published by The Ballantine Publishing Group

Copyright © 1995 by Byron Preiss Visual Publications, Inc.

Cartoon Bank Credits: Mort Gerberg © 1995—75. Mick Stevens © 1995—130. Robert Mankoff © 1995—141. Jack Zeigler © 1995—206.

The Cartoon Bank, Inc., located in Yonkers, NY, is a computerized archive featuring the work of over fifty of the country's top cartoonists.

Illustration credits: © Archive Holdings—76, 88, 139, 212.

Permissions to reprint art appear on pages 238–240.

Fawcett and colophon are trademarks of Random House, Inc.

Library of Congress Catalog Card Number: 94-94572

ISBN: 449-90698-1

www.ballantinebooks.com

Cover design by Pixel Press

Manufactured in the United States of America

20 19 18 17 16 15 14 13 12

First Edition: February 1995

CONTENTS

WHAT IS ART ANYWAY?

"YOU CALL THAT ART? MY KID COULD DO IT!"

A rt is more than just a three-letter anagram for the words *tar* and *rat*. Throughout civilization, art has been used to express the entire range of human feelings and spiritual beliefs. A sandstone Buddha made during India's classical fifth-century Gupta period is the very picture of enlightenment and serenity, while the crucified Christ in Mathias Grünewald's sixteenth-century Isenheim Altarpiece communicates profound and redemptive suffering. A Roman-era equestrian statue conveys nobility and grandeur, a Suprematist painting from the early years after the Russian Revolution expresses utopian idealism, and Warhol's portrait of Marilyn Monroe symbolizes glossy Hollywood celebrity.

The goal of art history is to help illuminate all of these ideas and, by extension, the societies from which they spring. Today we think of art as a dismally low-paying profession that requires unusual amounts of creativity, imagination, and skill. With luck and hard work, a contemporary artist dreams of showing his or her paintings

or sculptures at galleries and museums or selling them at auctions for ridiculously large sums of money.

Our notions of art and artists, although rooted in the older traditions of Greece and Rome, are fairly recent developments springing from European civilization. Even in Europe, it's only during the last few hundred years that art was created for museums or private collectors. Before that, art was intended either for the church or for the king and his court. On other continents and in other times art had different functions. Art was part of a magic ceremony or served the gods or ancestors. In ancient times art may have been made by all members of the community together, rather than by professionals alone. In aboriginal civilizations, for example, what we call art is but one aspect of the community rituals that are designed to ensure a good hunt or to celebrate a birth, a death, or some other life transition.

In every society, art has a special place. It is part magic and part science, part truth and part imagination. Art helps define morals, history, and beliefs. Art helps deliniate the structure of society, of communities, and of families. It is a form of communication that goes beyond language to forge mythical links within the tribe, with the gods or with the forces of nature. People express themselves artistically to impose their will on the material world and secure immortality for themselves. The most successful artists today sell their art for enough money to buy imposing things in the material world.

ALL THOSE ISMS

What is art history anyway? History is gone, it's all over,

in the past. Art is something that's here, something you can see and touch (if the museum guard isn't watching). Some art has been saved for years, sometimes for hundreds or even thousands of years. Art is often the only thing that has survived from ancient times. Art is something that was made to be saved, a special thing that became a repository of culture.

Art history is the study of this stuff. The art historian sorts objects into classes by similarity and period. An art historian will survey a huge group of similar things—say, Renaissance paintings of Mary and the baby Jesus—and look for common traits. The art historian will look at each painting's iconography, meaning its subjects, symbols, and themes. In a Renaissance Madonna and Child, for example, he or she would examine the poses of the figures, the positions of their hands, their manner of dress, the direction of their gazes, and other objects and symbols within the picture. Finally, the art historian performs what is called a formal analysis, studying the way the artwork is made as an object of design. The art historian considers the way the artist has used the factors of his craft: space, mass, line, color, perspective, proportion, volume.

The father of official art history was a German named Johann Joachim Winckelmann (1717–68). The son of a poor cobbler who arrived in Rome at age thirty-eight, Winckelmann was the first art lover who tried to tell the difference between Greek art and Roman copies (before him it was all just antique). He had some other ideas that might sound familiar: Art is best if it imitates nature; art should uphold moral principles; art is the most noble manifestation of a nation's spirit. Alas, even then no good deed went unpunished. In 1768 Winckelmann was

murdered in Trieste by robbers who may have been after some gold coins he had been flashing around.

If you spend any time with art historians, you'll realize that the field is basically divided into two camps: those who believe that art is about form—that is to say, its colors, shapes, and stylistic development; and those who think art is about its social function—who owns it, why it's made, and what is its general cultural meaning. Heinrich Wölfflin (1864–1945) was a pioneering authority in the formal stylistic analysis of motifs and composition in art. An important advocate of the social interpretation of history was the art historian Jacob Burckhardt (1818–97), who wrote *The Civilization of the Renaissance in Italy* (1860). Burckhardt related art to its cultural environment. These guys did their writing in German, so if you're serious about studying art history, you'll eventually have to *sprechen sie deutsch.*

By Winckelmann's time, Europe had invented a specific art form that no one else used—the easel picture. Conceived as a window onto a real or imaginary world, the easel picture arose with the development of a number of *trompe l'oeil* (French for "fool the eye") techniques that make a flat surface look three dimensional. Linear perspective is one; chiaroscuro, or the use of light and dark to mold form, is another. The easel picture took on a unique position in society as a commodity. No longer was art stuck to the wall of a church or painted especially for a palace. Art had become an object that everyone could buy and hang in their homes as decoration. It was so portable, in fact, that it gave the profession of art thievery a major boost.

THE ARTIST THROUGH THE AGES

When you said your kid could do it, you were right! Art by children has many qualities that we like; it seems natural, honest, bold. Curiously, children's art is hardly ever saved—at least, not by anyone other than the artist's mother. But ever since there have been walls, kids have drawn and doodled on them. A 1520 painting by an Italian painter named Giovanni Francesco Caroto depicts a grinning boy showing his stick-figure drawing.

Children's art demonstrates the way in which all people possess a kind of natural artistic talent, the bedrock upon which all art grows. The task here, then, is to examine the social circumstances that lead to the incredible flowering of all the various things we call art.

What roles has the artist taken through the ages? Looking back through (admittedly biased) modern eyes, we presume that many primitive and ancient societies granted their artists a special priestlike status. The artist functioned as shaman, a conduit for the gods on earth, a holy man. The Romantics of the eighteenth century revived this artistic role with a little self-consciousness. During the Romantic era, the artist was a grand figure who identified his imaginative energies with God's creative powers. For the Romantic, the artist and his originality was the be-all and end-all. This idea still reigns. In contemporary society, the artist continues to be thought of as a person with a special imaginative gift.

In earlier ages, of course, the artist wasn't such an egomaniac. The anonymous artists of the Middle Ages in Europe and of ancient cultures on other continents were supreme craftsmen, working in service to their masters and their god. Medieval artists were more interested

in following the canon, the divinely inspired guidelines and rules, rather than striving to create something new.

Readers of a biography of Diego Velazquez, the great Spanish Renaissance painter, will be surprised to discover that this artist, who could create incredibly moving pictures of holy scenes as well as unbelievably sophisticated portraits of some of the ugliest, most inbred royal families in history, was obsessed with his position at court. Sure, he had to wear a high ruffled collar to breakfast, but what a small price to pay for unlimited falconry, a box seat at public floggings, and other such perks.

Somehow, being a member of the court—akin to a court jester, perhaps?—doesn't jibe with our views of the artistic enterprise today. But artists weren't always tortured loners. In medieval times, European artists were organized into guilds, which gradually evolved during the Renaissance into national art academies. Every country had one. Originally the guilds and academies promoted high artistic standards, but by the nineteenth century their influence had become stifling—even the Impressionists were rejected from the official salons. The French came up with a great word for academic painters who took no risks: *pompier*. Its literal meaning is pumpmaker or fireman, but the word could be better translated as "stuffed shirts," since it described art that was pretentious, trite, and stereotypical.

The artist will always remain, to a degree, a servant of his client, whether that client is a god, the church, a king, the community at large or an art dealer. The question is how this service is manifested. For example, in medieval times, unnamed artisans and calligraphers would labor endlessly to create beautiful illuminated bi-

bles for their king or their cardinal; these books were made for one or two people only and seen by only a handful more.

As for today's artist, he or she is supposed to exercise his or her creative genius in solitude. The artistic inquiry is considered a pure one, uncontaminated by outside pressures. Except for the occasional bourbon break at scruffy bars, of course. There are collectors who pay money for the art these bohemians make—of course, on occasion they pay substantial sums. But according to our contemporary myth of the artist, he or she rarely sees the collector and his money; the art dealer is the intermediary who insulates the source of creativity from that root of all evil, the customer who needs something to match a blue couch.

The stereotypical isolation of the starving artist working alone in his garret—an image that can be traced back to the Romantic movement of the nineteenth century—further limns a special aspect of his or her character. Possessed of a unique eccentricity, the artist supposedly travels the tightrope between the everyday world and insanity. If he cuts off his ear, he probably *is* insane. In fact, the French artist Jean Dubuffet, after World War II began ardently championing the art of the insane. He saw in their mad scribbles and obsessive scenes an entrance into the human mind that could be found nowhere else—except, perhaps, in the art of children.

FROM THE MUSEUM TO MTV

If you think it's hard telling the insane artist from the genius, try tackling that other artistic dilemma: How do

you separate high art from popular culture? Or do you? Alongside the fine art that inhabits our museums, we have tons and tons of what is called *kitsch,* commercial art of dubious taste. Things like clowns with sad faces, little kids with great big eyes and Elvis in Day-Glo on black velvet. More importantly, modern culture is awash in images. Picture books and postcards and posters, newspaper photos and comic books, snapshots and advertisements and graffiti and doodles. And movies. And television. Tons and tons of it. A veritable primordial swamp of images. How could the inner life of modern man help but be anything other than "an appalling farrago of banalities," as one contemporary critic put it not too long ago? Well. As soon as we figure out what a farrago is, we'll let you know.

More than ever we live in an image culture. What place does high art have in it? Hierarchies and distinctions in culture are a central preoccupation, not only to esthetes but also to businessmen. Art is defined as a special thing with unique qualities, like beauty or craftsmanship. But art is also defined by its context. Art is what you go to a museum to see. Art can also be found in the artist's studio, at art galleries, on collector's walls and, increasingly, in building lobbies and public plazas and the subway.

Although many purveyors of fine art would like to wall off their enterprise from anything low or base, in fact the imaginary membrane separating high art from low is as permeable as a paper plate of Chinese food. Since the Renaissance, artists have used sources from popular imagery, whether it was Géricault painting *The Raft of the Medusa* in 1817 from newspaper reports of the tragic scandal of the day or the Pop artists in the 1960s emulat-

ing and elevating items of popular culture to high art status.

Today, art comes in many forms, suitable to a modern, industrial, urban society. At the same time, we prize art from earlier ages. Throughout it all, art creates a kind of zone of imaginary freedom, where history comes alive, where anything is possible. Hold onto your hat, and turn the page.

ART
HISTORY

PREHISTORIC ART

YOU MUST REMEMBER THIS

From the beginning of time, people the world over were decorating their living quarters with sketches of animals, abstract pictographs, clay figurines and knick-knacks of all kinds.

BEST KNOWN FOR

Pet rocks! Over 25,000 years ago, the beatniks of the Stone Age were already making simple and expressive artifacts that symbolized their world. Then they buried them so we could find them later.

CAVEMEN DO IT BEST

Sculpture and painting originated during the earliest period of human history, called the Paleolithic period or Old Stone Age, which began about two million years ago. Primitive peoples began to develop beliefs in magic and the supernatural, one of art's all-time favorite subjects. We also see humans of that time engaging in other forms of artistic behavior, adorning themselves with bone and antler beads and pendants, for instance, and decorating their tools and weapons with designs and little pictures.

Crafts like pottery and weaving, as well as writing and more highly developed forms of painting and sculpture, turn up during the Neolithic period, or New Stone Age, around 8000 B.C. to 1500 B.C. This is the culture of farmers and city slickers, when people began to settle down and cultivate crops and gather into cities. Neolithic cultures continue to exist in our own day in more primitive areas of the world, such as the Yamomani Indians in the Amazon (Sting and other rock stars are championing the preservation of their endangered jungle habitat).

IN THE BEGINNING

No sooner had our beetle-browed forebears learned to strike one rock against another than they started making art, or so the archeologists would have us believe. For us today, Stone Age art provides clues about the most basic elements of human culture at the very dawn of civilization. In other words, before Beavis and Butthead, but nevertheless very much like them.

How old is the stuff? It's hard to tell, but get this: A

lump of red paint that dates back around 250,000 years was found in a cave. Where? In Bohemia, no less, part of what is now the Czech Republic. Bohemian even then.

That's a rare early find. More recently, from about 35,000 years ago, all kinds of great stuff begins to turn up. Engraved animal bones and eggshells, beads, stone amulets, terra-cotta and ivory figurines, wall paintings, and rock carvings. The art business really takes off, though, after the end of the last Ice Age, around 10,000 B.C. (and continues to this day).

ART AND SEX

During the earliest part of the Stone Age, known as the Upper (or Late) Paleolithic (25,000–15,000 B.C.), statuettes like the Venus of Willendorf are found across Europe from Spain to Russia to the banks of the Tigris in Mesopotamia. Archeologists believe that these feminine fetishes represent a cult of the Mother Goddess, the incarnation of fertility. These figures, simple and voluptuous, are made of stone, bone, ivory, and clay. They frequently are given incised hair in curls or braids, simple garments or belts, and are sometimes pregnant. The occasional phallus has turned up as well. Universal art rule number one: Sex sells.

TALKING TO THE ANIMALS

Give a herdsman or a hunter a nice wall and some crushed mineral pigment, and before you know it he or she is making pictures of Bambi, Thumper, Mr. Ed, Dumbo and the rest of Dr. Doolittle's menagerie. What for? Who knows! Maybe for magic, maybe for ritual, maybe for storytelling, maybe just for fun.

**WHO'S
H
O**
☞

Stone Age people—which include the first Homo sapiens, our remotest ancestors— learned to make crude stone tools (thus the name), build simple shelters and sew clothing. To survive they ate nuts and berries and fished and hunted, which is why anthropologists like to call them hunter-gatherers. And they made art, all kinds. For example:

The Panaramitee petroglypher, c. 43,000 B.C.
Aborigine abstractions! The world's earliest known abstract art are the mysterious petro-glyphs—mazes, spirals, circles and other marks—at Panaramitee in South Australia.

The Venus of Willendorf carver, c. 30,000– 25,000 B.C. (see fig. 1.1)
Hubba-hubba! All breasts and belly, this 4½-inch-tall carved limestone figure, found in Aus-tria, is almost certainly a fertility figure. And that hairdo. Divine!

The Lascaux cave painter, c. 15,000–10,000 B.C.
Dances with wolves! Incredibly naturalistic pic-tures of bulls, horses, mammoths, lions and other animals—hardly ever men and never women—painted in deep underground caves on wet limestone walls with powdered min-eral pigments.

The Stonehenge builder, c. 2100–2000 B.C.
Architecture rules, dude! On Salisbury Plain in England is Stonehenge, the mysterious celestial calendar that New Agers love so much today.

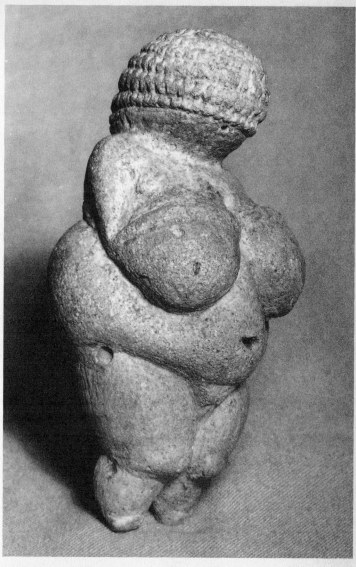

1.1 *One of the earliest representations of a human, this portly maiden is known as the "Venus of Willendorf" and was made about 25,000 B.C.*

Archeologists have found prehistoric art in caves in Namibia (c. 24,000 B.C.), in shelters at Bhimbetka in central India (c. 11,000 B.C.), on rocks in the Sahara (c. 8000–5000 B.C.), in a complex of mud-brick houses in Turkey (c. 6000 B.C.), and in the Amazon region of South America (5000 B.C.).

By the way, don't think that the earliest artists were necessarily male cavemen. Those stencils of hands found from Spain to Australia, which are produced by blowing powdered pigment through tubes over a hand held up to the wall, are the same size as bones of women.

When cave art was first discovered in the late 1800s in Spain at Altamira and in France at Lascaux (see fig. 1.2), it looked so fresh that most people thought it was some kind of hoax. Alongside the figures of people and animals are often found strange geometrical symbols. Besides those and the ones at Panaramitee, pictograms were left by primitive cultures in Ireland, Peru, Hawaii, and the American Southwest, among other places. They've been given contemporary names depending on what they look like, for instance, *claviforms* are clubs while *aviforms* are birds in flight. The second basic rule of art: If you can't figure out what it is, give it a name no one will understand.

DECORATION

Our earliest ancestors probably had a big body makeup thing going, but who can tell now? And anything made out of feathers, mud, wood, animal skins and the like is bound to be long gone. But you know cave folk must have gussied themselves up first chance they got. By 10,000 B.C., people in what is now Israel

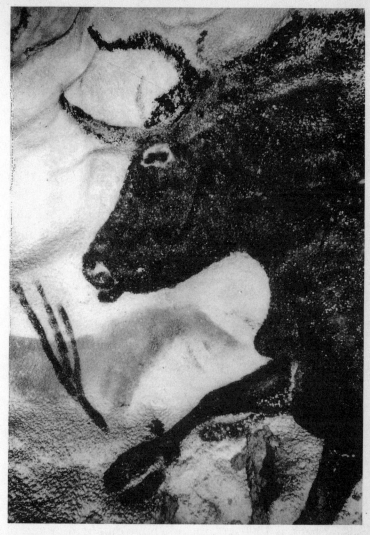

1.2 *The Flintstones' version of Photorealism: Painted bison clamber across the rock face of a cavern at Lascaux, France. These images were created around 16,000 years ago.*

were burying their dead along with necklaces made of shell and bone beads. And necklaces, pendants and earrings made of animal teeth (dating around 7500 B.C.) have been found in northern China and Manchuria. Later, the French picked up the jewelry thing and so invented fashion accessories.

ART AND ASTRONOMY

What did cavemen and cavewomen do after dark? (No, no, no, not that. *Besides* kissing and hugging.) They looked at the night sky and invented constellations and figured out the celestial logic of the universe. Then they created monolithic heavenly astrolabes like Stonehenge and vast drawings of weird creatures like those at Nazca in Peru that can only be seen from a heavenly vantage point.

To build Stonehenge, in about 2100 B.C., huge bluestone megaliths were hauled from the mountains of Wales to Salisbury Plain some 190 miles away. The stones of Stonehenge are aligned to mark the summer and winter solstice. About a hundred years later, the outside circle of sandstone sarsens were brought from twenty miles away and added to the monument. The idea that Stonehenge was a temple of the Druids in Celtic Britain (c. 300 B.C. to A.D. 200) was popularized during the eighteenth century.

The Nazca lines along Peru's southern coast, dating as far back as 1000 B.C., include huge outline drawings of hummingbirds, monkeys, spiders, and geometric figures. They were made by removing the brown surface stones to reveal the lighter ground beneath. Probably made for

an audience of sky gods, the lines may also have astronomical meaning.

So what does it all mean? No one really knows. It seems downright inconsiderate of our illiterate forebears to make these awe-inspiring expressions of a cosmic mythology without leaving a clue behind as to what they're all about. Art rule number three: Leave your audience guessing.

SUMMARY

As far back as 40,000 years ago, ancient peoples the world over, from Australia to Africa to Europe, were making little statues and rock drawings, probably for magical rites connected with fertility and hunting.

THE ANCIENT WORLD

YOU MUST REMEMBER THIS

Early civilizations developed an art of elegance and complexity. In these increasingly complex societies, the first professional artists (still mere workers and thus unnamed) crafted either grave goods to be interred with dead rulers or monuments to mark their reigns.

BEST KNOWN FOR

Sumptuous art fit for kings, more or less stylized, more or less religious, more or less naked.

PINUPS IN THE GOLDEN AGE

Humans invent the wheel, metallurgy, writing, money, cities, bureaucracy, warfare, and a lot more—in short, it's the dawn of civilization. And even without the fruits of civilization, like sitcoms and car payments, ancient artists had time to become really skilled. Although technical aspects of art have continued to develop gradually over the years, art's esthetics—its beauty, craftsmanship and, spiritual power—ran at full throttle from the beginning. That's why they call great art timeless.

MASTER OF ANIMALS IN THE GARDEN OF EDEN

Somewhere in the desert, long, long ago, emerged the earliest civilization on record. Little is left behind: your occasional mud-brick ziggurat, your occasional stone monument. But what the Mesopotamians did have was a lot of wet clay. They made clay tablets for their cuneiform (pictographic) writing, which they invented (and used to write the Gilgamesh Epic, one of the world's earliest legends). More importantly for the visual arts, they used clay for their cylinder seals, a kind of rolling stamp used to seal storage rooms and containers.

The elaborate if tiny pictures in these clay impressions provide much of the visual record of early Mesopotamia—which is supposed to be the locale of the biblical Garden of Eden. Sure enough, the many ancient cultures uncovered there (Sumerians, Akkadians, Babylonians) have a bare-breasted snake goddess that could conceivably pass as Eve. Another Old Testament instance

are the figurines of winged bulls with human heads that could well be the kind of idol the biblical prophets complained about.

THE CURSE OF THE MUMMY'S TOMB

What is Egyptian art? Half-dressed people and their pets, for one thing. Looking altogether too fit, for another. What diet were they on, anyway?

WHO'S WHO ☞

Four of the major sites:

Mesopotamia, c. 4000 B.C.
Bug-eyed god-kings, bearded bulls, and ziggurats (giant stepped pyramids) in the cradle of civilization between the Tigris and the Euphrates rivers.

Egypt, c. 3000–330 B.C.
Pharoahs, pyramids, and pictograms. Hey, they were just trying to figure out how to write.

Greece, 1200–200 B.C.
Temples, statues, paintings, and pots by art's first egotists, who set the standards of excellence that are the basis of all Western art, not to mention bank facades everywhere.

Rome, 700 B.C.–A.D. 500.
If you can't make it, take it. Rome conquered Greece, adopted its art, and, generally speaking, made it bigger.

The development of an intricate and detailed figural art, mixed with a system of hieroglyphic writing, marked the increased complexity of human society. Its job was to teach, communicate, and control.

Egyptian art features a pantheon of supernatural beings that rival Saturday morning cartoon shows. Besides kings and queens and ordinary Egyptians, tomb paintings are peopled with the sun god Ra, who takes the form of a cat, patron goddesses who appear as vultures and cobras, plus an array of lesser hawk-headed, ape-headed, and jackal-headed deities, to name a few. We're talking major comic book panels.

The Egyptians believed in a kind of eternal life after death, with things being more or less like they were while they were alive. Consequently, the wealthy would invest in elaborate tomb paintings depicting the good times they hoped to enjoy in the netherworld. They'd fill the tomb with statues, ornaments, and anything else they might need. Kind of like an eternal fall-out shelter.

Egyptian art, Plato liked to say, didn't change for 10,000 years (Plato, with his crypto-tyrannical belief in absolutes, thought this was a good idea). Actually, the famed civilization of the Nile lasted only around 3,000 years, but who's counting? The important thing to know is that during all that time Egyptian art hardly changed, setting some kind of record for conformity and convention in the creative sphere. As everyone knows, the Egyptians invented hieroglyphics, a sort of picture language that uses logotypes for words. What we don't know is the sort of distinction the Egyptians might have made between this picture-writing and more fully developed representations of things in the world (i.e., art). In one small limestone relief from Itwesh, c. 2475–2345 B.C. (see

fig. 2.1), for example, carved relief words are juxtaposed with a surprisingly realistic profile of an Egyptian man. Is he speaking these words, as in a cartoon bubble? Is he described by the words? We just don't know. But the man is typical of Egypt's processions of static, symmetrical figures painted in flat colors, with the head and legs in profile and the torso that faces front. Walk like an Egyptian.

Around 1600 B.C., the Egyptians also invented costume jewelry when they discovered real gems could be replaced with paste and cast-glass imitation. Zsa Zsa Gabor thanks them.

HOMES OF THE STARS

Those pesky civilizations that flourished in Europe and the Near East, only to disappear a millennium or so later, are so confusing! Their names sound more like new nightclubs than ancient cultures. What country are their ruins found in, anyway? A handy guide:

Sumerians, c. 4000–2000 B.C., Iraq.
Babylonians, c. 2000–323 B.C., Iraq.
Cycladic, c. 3200–1800 B.C., Greece
Minoans, c. 2500–1400 B.C., Greece.
Mycenaeans, c. 1600–1100 B.C., Greece.
Hittites, c. 1700–1200 B.C., Turkey.
Phoenicians, c. 1500–146 B.C., Lebanon.
Assyrians, c. 1520–612 B.C., Syria & Iraq.
Persians, c. 550–480 B.C., Iran.
Celts, c. 500 B.C.–A.D. 450, Ireland and Western Europe.
Etruscans, c. 800–100 B.C., Italy.

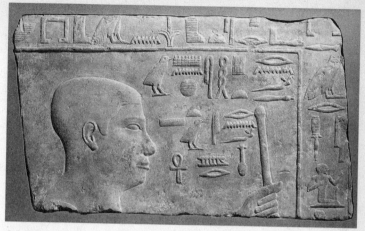

2.1 *This limestone relief, known as the "Relief of Itwesh," is only 16 inches high and dates from about 2400 B.C.*

MARTIANS IN THE MEDITERRANEAN?

About 2500 B.C. a bronze-age culture grew up in the ring of islands between the Greek mainland and Asia Minor called the Cyclades (which means "those in a circle" in Greek). Little is known about this tranquil civilization, except that its artisans used the plentiful local white marble to carve highly stylized statuettes of skinny nude women with their arms crossed. We can only speculate about the meaning of these mannered, geometric figures. Perhaps the first appearance of the waif look?

Cycladic civilization is also where we find, for the first time in the ancient world, an example of the herringbone design, incised on clay jars about 3000 B.C.

SAY CHEESE

Big-time Greek culture, the one they call the birth-place of Western civilization and individual freedom, really gets going around 900 B.C. Not much is left but pots, though they presumably reflect lost wall paintings and monumental sculptures. The earliest Greek vases are decorated with a range of geometric patterns: zigzags, meanders, chevrons, checkerboards, diamonds, and rosettes. After about 150 years of this, the pot painters start drawing little figures and scenes among the ornamentation, and before you know it you have episodes from the Homeric epics and the Labors of Hercules illustrated on your cups and saucers (just like the images of Tom and Jerry on your Welch's grape jelly jars).

This marks the beginning of the full-blown visual narrative in art, which a few millennia later eventually led to the invention of comic books, not to mention a Hollywood career for actor Steve Reeves, the muscleman who played Hercules and other Greek heroes in the B-movies of the 1950s.

After another 150 years or so, at the beginning of the Archaic period in the sixth-century B.C., Greek artists had gotten amazingly good at painting pictures on the sides of pots, and finally started signing their work. The first autograph to appear on a vase was that of an artist named Sophilos, on a large wine bowl decorated with a wedding scene. In all, about five hundred pot painters have been identified, with Exekias and Euphronios among the more celebrated.

Archaic Greek art is also marked by new large-scale carved figures of naked young men called *kouroi* (singular: *kouros*), made either to mark a grave or in honor of

BOOZING IS SERIOUS BUSINESS

For wealthy Athenians, the *symposium,* or drinking party, was where the action was. And they liked to have their wine, which they mixed with water, in a nice container. The shape was as important as the decoration, if not more so. After all, a well-proportioned vessel enhances the pleasure of a good drink. At least for the first dozen glasses, after which most of us are likely to be having it straight from the bottle. Some basic vessels:

Wine jar: Amphora or pelix.
Water jug: Hydria.
Mixing bowl: Krater.
Jug: Oinochoe.
Cup: Skyphos, kalyx, or kylix.

The designs were beyond clever. Like a ring of waterbirds painted around the inside rim, as if they were parading around the shore of a "wine-dark sea," as Homer called the Aegean. Or huge eyes painted into the design on the outside of the cup, as if to watch for trouble while the drinker quaffs.

a god. A typical kouros statue is this one (see fig. 2.2), c. 600–580 B.C., in the Metropolitan Museum. It is carved from a single block of marble and, at 72 inches in height, is just about life size. The figure is simplified and idealized: muscles, such as those over the knees, are detailed in an abstract way and the proportions of the human figure have been regularized and made symmetrical. Though stiff (almost Frankenstein-like), the kouros marks a dramatic step toward an exact replication of the appearance of the human body.

Oddly, many of these guys wear a blissed-out expression with a hint of a grin or a smirk. Who knows what they're so tickled about? Could it be the female statues? Called *korai* (singular: *kore*), they're more often draped than not and depicted with elaborate braided hairdos. Art's enigmatic smile doesn't reappear until the Renaissance, with Leonardo's *Mona Lisa*.

ARISTOTLE'S ESTHETICS

The father of all art critics is the ancient Greek philosopher Aristotle, who more or less invented aesthetics in his *Poetics*. Aesthetics is the branch of philosophy dealing with questions of beauty and art. Some of his main ideas:

- Art is an imitation of reality—art holds a mirror up to nature.

- Beauty is an objective quality of a thing, not a subjective response of the viewer.

- Art should strive for unity of form (without confusing digressions).

- The goal of art is to represent the inner significance of things, not just their outward appearance.

- The function of art is catharsis, the purification of antisocial emotions and destructive impulses forbidden by society.

- Art appeals to the intellect as well as to feelings, which if properly combined can give the highest form of pleasure.

CLASSICAL GREECE

In Classical Greece, which runs from the fifth century

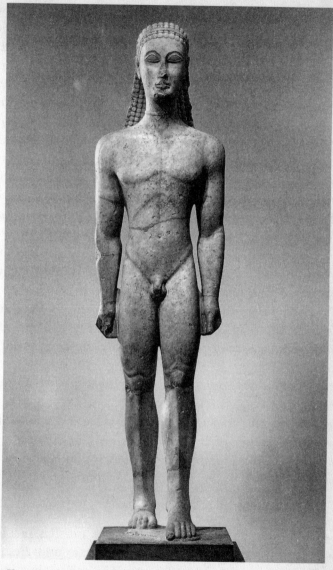

2.2 *Kouros statues such as this appear very stiff, but to the Greeks they were strikingly realistic depictions of living men. This lifesize marble statue was made around 600 B.C.*

B.C. to the death of Alexander the Great in 323 B.C., we see the widespread mastery of anatomy, spatial illusionism, and naturalism in art, focusing (still) on the depiction of the human body. The beautiful becomes a reflection of noble spiritual and moral qualities. The sculptor and theorist Polykleitos comes up with the first canon of ideal proportions for the human body—inventing, as it were, the first supermodel. His bronze statue *Doryphoros,* made around 440 B.C., though lost and known only from description and from Roman marble copies, was famous for popularizing the relaxed stance that puts the body's weight on one leg, as in Michelangelo's *David.*

One interesting thing about Greek painting is that top-quality examples, notably works by fabled masters named Apelles, Polygnotus, and Zeuxis, have all perished over the ages. Some surviving wall paintings and mosaics give an idea of what Greek painting was like, though, and ancient writers refer to painters and painting frequently enough. Like in Greek vase paintings, the subjects were usually either action scenes or quiet tableaux, most drawn from mythology. The artists used wood panels, terracotta slabs, pieces of marble, walls and sometimes pieces of leather or linen to paint on. They had a basic range of colors, mixing their pigments in water (tempera) or with wax (encaustic) and painting on plaster or stucco (fresco). Oil painting hadn't yet been discovered.

Polygnotus, the first great master of Greek painting, worked in Athens from about 480 B.C. on. His pictures were celebrated for their expressiveness, and he was credited with a number of artistic innovations, including being the first to paint hair in different colors and the first to paint women wearing diaphonous garments. The

Greek painter Apollodorus, a contemporary of Polygnotus, was nicknamed "shadow-painter," supposedly because he was the first to give a 3-D effect by shadowing his figures. The work of Apelles, the painter to Alexander the Great (356–323 B.C.), is known only from provincial copies of his works discovered in frescoes in Pompeii.

Zeuxis, another Athenian painter active in the second half of the fifth century B.C., is said to have been a master of light and shade, and the first artist to place his figures in landscape settings. Pliny the Elder (A.D. 23–79), in his *Natural History,* tells a story about a contest between Zeuxis and another Athenian painter, Parrhasius, to see who could make the most realistic painting. Zeuxis's picture of some grapes was so true to life that birds flew down to eat the fruit. Zeuxis then demanded that his rival draw the curtain to show his work—but Parrhasius was in fact displaying his painting, which was a picture of a curtain. Zeuxis had to admit that Parrhasius had won the contest.

Classical Greece was also the place to go for temple

VENUS DE MILO

Funny that the Greeks get credit for creating the feminine ideal, since their model of beauty was a well-proportioned young male body. Anyway, the famed marble Aphrodite, sculpted by Agesandros of Antioch in the second century B.C., became the Western symbol of female beauty during the nineteenth century. Now in the Louvre, she measures a larger-than-life 6-foot-8-inches tall, a real Amazon. Nobody knows how her arms were posed, or what happened to them. Perhaps they were stolen by armed robbers?

architecture, the orgin of all those classical fluted columns we see on banks and state capitols across the land.

After Athens kicked the Persians out of Greece in 479 B.C. they decided to celebrate the triumph of Greek civilization over the barbarians in the rest of the world. The showpiece of the huge public-works explosion was the Parthenon in Athens, built in the Doric order by Iktinos and Kallikrates in record time during 447–432 B.C.

THE ROMAN ERA

Gradual Roman conquest of the Greek world was marked by Roman plunder of art treasures on a massive scale—a lasting tradition, as it has turned out. Wealthy Romans who filled their villas with the stuff can probably be called the first collectors. In turn, the Romans also boast the first reactionary art critics, such as Cato the Elder, who warned that Greek sculpture was a corrupting influence. The Emperor Augustus, who ruled from 31 B.C. to his death in A.D. 14, established the tradition of arts patronage, promoting a revival of the classical Athenian style throughout his empire. In Roman times everyone thought the Classical Greek age was the greatest, so Augustus embraced Greek art in order to prove continuing Roman cultural superiority.

Besides understanding the value of the spoils of conquest, the artists of Rome understood the magnificence and grandeur that comes from super-large scale. Thanks in part to the discovery of concrete in the second century B.C., the Romans were able to build huge triumphal arches all over the place and giant buildings like the Colosseum (A.D. 80) and the Pantheon (A.D. 125) in

Rome. The Roman propensity for hugeness culminated in an 8½-foot-tall bust of Constantine the Great in A.D. 330, in the final days of the empire.

Roman art had a great range. The Roman empire lasted more than one thousand years, after all, and stretched at its height from Egypt and Armenia to Spain and England. Palaces of the wealthy were filled with intricate mosaics and murals depicting everyday scenes as well as episodes of myth and fantasy. Rome's long tradition of portraiture achieved exceptional degrees of realism in its marble busts of everyone from freedmen to the aristocracy—originally depicted with their noses, which only got knocked off later.

Another legacy of Roman art is the very concept of civic sculpture. One of the most famous sculptures, which you can still see in place in the Piazza del Campidoglio in Rome, is the bronze equestrian statue of Marcus Aurelius. This over-lifesize statue from the second century is a portrait, but it is also a political monument; everything is geared toward stressing the ruler's power. The site of the sculpture (on a high base, amid important government buildings), the surprising detail and naturalism of the depiction, the calm authority of the figure, the disproportion in scale between rider and horse (not to mention the figure of the barbarian who once lay under the horse's hooves!) all made clear to the viewer that this was no guy to mess with.

So you can blame the original republicans for those alarming (or boring) statues of dudes on horseback that greet us in every city square, not to mention their latter-day kin, contemporary public art of all kinds.

Early civilizations around the Mediterranean begin-
ning around 4000 B.C. were marked by the wide-
spread use of images of people, whether rulers or
commoners, whether idealized or realistic.

TALES OF FOUR CONTINENTS

YOU MUST REMEMBER THIS

Out of seven continents, the only one with no artists on it was Antarctica (too cold for people of *any* vocation). From the Stone Age to our own age, peoples from the Americas, Asia, and Africa used art to articulate their religious beliefs, depict the human body and decorate the items of everyday life.

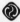

BEST KNOWN FOR

Art that's part of everyday life rather than put on a pedestal or hung on the wall. In Asia, it was calligraphy and kimonos; in India, it was erotic temple sculptures; in Africa, it was ritual masks and erotic dance; and in pre-Columbian America, it was stone temple carvings and jewelry of precious metals.

ART MAKES THE WORLD GO 'ROUND

This will be a quick survey, we admit, really no more than the sort of view you get from the tram traveling through Pirates of the Caribbean at Disneyworld—equally cursory, equally exoticizing. But, if nothing else, it will provide an introduction to non-Western cultures and help place Euro-American developments in context.

WHY THEY BUILT THE GREAT WALL

The Great Wall was constructed to keep nosy Europeans out of China. Well, it didn't work. Even Nixon went to China. Nonetheless, as a result of prior centuries of isolation, Asian art comes as something of a surprise to Westerners. Works from all periods are teeming with richly jewelled figures, amorous couples, monkeys, peacocks and other fabulous creatures. What do they mean? And how can we understand the different forms if we don't speak the language, so to speak?

First, consider the lay of the land. Asia comprises of a vast geographic area that is dense with culture, so dense it doesn't seem to make sense, constantly shifting in both political and religious terms. No wonder the European mapmakers, who decided what continents were what, elected to lump this vast and varied area into a grab bag called Asia.

CHINA BEFORE MAO

During the final years of Mao Tse-Tung's long rule, an important archeological discovery was made. A huge cache of life-size clay figures of warriors in battle gear

WHO'S WHO

How can anyone be expected to understand the variety of art styles that span four continents and several millennia? The usual way to sort it out is by continent: Asia, India, Africa and the Americas (before Columbus).

Asian art, influenced by Buddhist, Hindu, Muslim and other faiths, developed refined and sophisticated courtly arts that narrated the lives of the aristocracy.

Indian art exhibits a great sensuality—including some sinuous poses and sexual positions we in the West don't even have names for—but was also profoundly shaped by Buddhist and Hindu religious beliefs.

African art is famous for skillfully carved wooden masks and sculptures that look like ferocious supernatural beings with weirder faces than all the guys in Wrestlemania put together.

Native American art of pre-Columbian era consists of everything from huge pyramids in the jungle to exquisite beadwork and hammered gold jewelry, most of it destroyed by European conquistadors.

were discovered buried beneath a construction site. These figures, excavated and sent on tour throughout North American museums in 1974, are relics of one of China's earliest and most despotic rulers, Emperor Ch'in Shih Huang Ti. When Ch'in died in 209 B.C. he had

over 500 of these warrior figures (and about two dozen life-size horse sculptures) buried with him as a kind of imperial bodyguard.

Buddhism arrived in China in the first century A.D., during the great Han dynasty (209 B.C.–A.D. 220), a period of unprecedented peace and prosperity, when internal strife was quelled and the Chinese empire expanded. At the same time, Confucian philosophy was formulated and advocated a code of social and moral order. Art was regarded as a valued component of this order. Finally, Taoism was also developed during this period. Taoism derived from the teachings of Lao-tzu, a sixth-century B.C. mystic, and emphasized the spiritual and the supernatural—you know, dragons and magic.

These various ways of looking at life were not necessarily antithetical and their simultaneous existence had a profound effect on the development of art in China. Objects reflecting different beliefs often are found side by side in tombs. Han dynasty art is courtly and delicate, consisting mainly of tiles and hand scrolls depicting the daily lives of aristocrats and court officials. Buddhism introduced a range of religious iconography, including the omnipresent image of the seated bald-headed figure of Buddha himself, but also ritual vessels and carved rock temples. Buddhist art was mainly public, designed for temples and public spaces. Much early Buddhist art is lost. By 845 A.D., Buddhism had become virtually the national religion in China, and the Confucians and the Taoists were upset. They got the emperor to ban all alien religion and order the destruction of more than 4,000 Buddhist temples and 40,000 shrines. More than 200,000 Buddhist monks were given pink slips. This derailed the development of art in China for a while, but soon there

was a Buddhist revival and by the millennium there was an extraordinary efflorescence of art.

During the Tang dynasty (618–907) there were a lot of weird pots with legs and dragons, a sure sign of Taoism. Painted scrolls and screens ignored perspective and conventions of light and shade, focusing on line and outline or silhouette. This was the period when Chinese landscape painting evolved, often in the form of sharply defined and intricately detailed scrolls.

The Sung dynasty (960–1279) is typified by elegant, minimalist glazed china pots. Landscape paintings continued to be popular but took a new form: hazy images of mountain peaks, trees and rocks executed as ink drawings.

When the Mongols under Genghis Khan conquered China in 1210, the warring states were brought under one rule. Western explorer Marco Polo, who visited the court of Genghis Khan's son, Kublai Khan in 1271, found splendors beyond his imagination. The connoisseurs of the court employed legions of professional artists and craftsmen to make elegant objects for their

A CHINESE CULTURAL CHRONOLOGY

Trying to sort out the various Chinese dynasties and figure out what art was made during which dynasty is harder than ordering at a Chinese restaurant. Here's a handy list from column A:

> Tang (618–907)
> Sung (960–1279)
> Yuan (1279–1368)
> Ming (1368–1644)
> Ching (1644–1912)

homes. Typical objects from this period are the rich horizontal scrolls or screens that are minimally decorated with images of bamboo or other plants. The thirteenth century was a period of revivalism in which artists looked to earlier Chinese traditions.

JAPAN BEFORE GODZILLA
AND KARATE

Japan is a string of relatively small volcanic islands with no native stone, so the early inhabitants of this land had to be quite inventive in making utensils and sculptures out of clay, cast bronze, or lacquer (figures made by soaking cloth in sap of the lacquer tree and forming it over wooden armatures). The world's earliest decorated pottery is from Asia: pots with patterned indentations from cords have been found in Japan and date from the Stone Age Jomon period, that is, about 10,000 years ago.

Jumping forward to more recent events, around 500 A.D. Buddhism was introduced to Japan from China and brought with it a form of religious representation characterized by grace, delicate openwork, and delight in surface pattern. Another influence was Shinto, a native Japanese religion involving ancestor worship. Shinto shrines, which shun pictorial representation for symbolic forms of notable dignity and simplicity, are destroyed and replaced every twenty years as a kind of devotion.

Later Japanese art is typified by utter refinement because, after all, this is the land of flower arranging and tea ceremonies. But Japanese art is marked by contradictions, a blend of sophisticated taste with vulgar subject matter—you can't go wrong.

The great art of the Heian Period in the eleventh cen-
tury is called Yamato-e painting. These horizontal scrolls
feature scenes of court life during the Fujiwara dynasty,
as outlined in the famous soap opera *The Tale of Genji*.
The style is marked by dramatic asymmetrical composi-
tions, areas of bright flat color and stylized figures of
people. There were also comic scrolls with animal char-
acters and other scrolls with tales of legendary monks
and magic. Later screens often represented the seasonal
cycles, sometimes with greater degrees of naturalism but
emphasizing harmonious pattern.

During the Askikaga period, from the fourteenth
through the sixteenth centuries, which saw the rise of
both the Samurai way of life and the spread of Zen Bud-
dhism, Japanese calligraphic artists mastered a style of
landscape painting that combined large monochrome
expanses punctuated by simple ink brushstrokes that
schematically indicated mountains, trees, and figures.
Doodling became high art.

Screen art was especially prominent during the Muro-
machi (1392–1573) and Momoyama (1573–1615) periods,
and the screens produced during this time—equivalent
to the High Renaissance in Europe—were increasingly
bold in terms of their design, color, and patterning.
Screens were fashioned from paper stretched over
frames, their surfaces covered with gold leaf and images
of flora and fauna. Their function was principally decora-
tive but they were also used as room dividers. The main
subjects of these screens were nature and aristocratic
court life. These themes were eclipsed by the more real-
istic, everyday content by Ukiyo-e printmakers of the Edo
period (1615–1857). Mass culture was born.

While early Japanese printmaking was limited to calligraphy with animal and plant imagery, the Ukiyo-e prints (meaning "pictures of the floating world," or pictures of trashy subjects) depicted kabuki actors, geishas, scenes of human foibles, and erotica. They were cheap and widely distributed, not altogether unlike the tabloid supermarket gazettes of our own time. An early master of the form, Moronubu (c. 1625–94), made many black-on-white woodcuts that were often hand-colored by their purchasers.

One great Japanese painter-engraver was Kitagawa Utamaro (1753–1806), who more or less invented the close-up (in Japanese art, anyway) and specialized in pictures of elegant ladies called *bijin* (that's Japanese for "beautiful girls"). Move over Hugh Hefner. Utamaro's *The Hour of the Horse* (c. 1795) (see fig. 3.1) is from a series of woodblock prints charmingly titled "A Sundial of Maidens." The Japanese day was divided into twelve units, each lasting about two hours and each represented by a symbol of the lunar calendar. At the Hour of the Horse, or noon, it was customary for young women to take their baths. The woman on the left in Utamaro's print holds a change of clothes and wipes water from her ear; the woman on the right holds a bran-filled scrubbing bag as she wrings out a cloth.

The last great master of Ukiyo-e was Katsushika Hokusai (1760–1849), who is known for the famous image of the *Great Wave* (1823) and whose fifteen-volume *Manga* provides an unparalleled record of Edo street life. The style, characterized by bold juxtapositions, flattened perspective, and everyday subjects, had a strong influence on turn-of-the-century artists like Whistler and van Gogh.

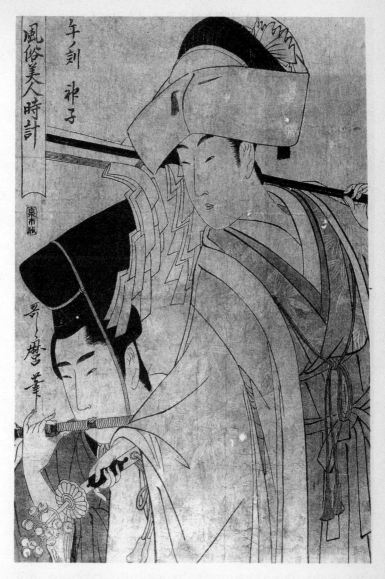

3.1 *A woodblock print called* The Hour of the Horse *by the Japanese artist Utamaro, c. 1795.*

INDIA BEFORE *GANDHI*

You could say that Indian art starts simple and almost abstract and, as the centuries pass under the influence of Hindu and Buddhist mythologies, explodes into intricate and sensuous detail.

Central to Indian art are religious images, whether Buddhist or Hindu. In India, temples are everywhere, their exteriors covered with sculpture. Between the seventh and twelfth centuries, largely in eastern India, highly ornate and sophisticated Buddhist art developed. Students of statues of the Buddha see a movement from relatively plain figures set against almost bare slabs to highly ornate compositions with the Buddha surrounded by upswept traceries of tendrils, fluttering banners, and mythical beasts. Later, Hinduism swept the nation, and with it came the terrifying and quite fantastic Hindu deities with lots of arms holding lots of stuff, plus weird hats.

During the Maurya dynasty, the first great Indian empire, the emperor Asoka (c. 269–232 B.C.) set up monolithic columns all over India except the far south. These pillars were about forty-five feet tall and crowned by carvings of animals—lions, elephants, and bulls. After conquering the subcontinent, Asoka became a Buddhist and inscribed his pillars with heartfelt apologies for the harm he'd caused (like, whoops).

The Buddhist monument par excellence is the *stupa,* or huge "world mountain," a domed, hemispherical burial mound surrounded by gates, palisades, fences, and stairs and surmounted by a platform topped with three umbrellas. A completely solid structure made of rubble faced with stone, stupas held enshrined relics of

Buddhist saints. The form of the stupa was symbolic—the dome represented the sky, for instance, and the umbrellas represented the gods of heaven. Gates which represent worldliness were constructed in ornate forms, with carved elephants, peacocks, and sensuous Indian nature goddesses who look like something out of the *Sports Illustrated* swimsuit issue from the first century A.D.

The image of the Buddha is central to Indian art. It makes its first appearance around the first to the early second century B.C., and remains relatively consistent in form. Buddha is depicted with elongated earlobes from heavy jewelry worn as a youth, halos of sanctity, and monastic robes. He is almost always shown sitting in a yoga posture, hands in *mudras* or sign-language gestures, though he is occasionally shown lying on his side. Pursuit of inner spiritual reality freed Indian art from a Western obsession with naturalism.

WHO'S WHO ☞

Asian Art

You can't tell the players without a scorecard, and religious deities in Asian art are notoriously hard for Westerners to keep straight. So here's a handy religious tout sheet.

Buddha
The chubby bald guy sitting in the lotus position comes in many guises. The historical Buddha—founder of the Buddhist religion—was a real person, known as Prince Siddhartha, who probably lived from 563 to 483 B.C.

**WHO'S
H
O**☞

(Continued)

Bodhisattva
Buddhas of the future, these religious sidekicks
could enter nirvana but instead stayed on earth
to help people.

Vishnu
Supreme god of Hinduism, incarnated on
earth in nine forms, including Rama and
Krishna.

Shiva
Hindu god of destruction and regeneration.
When dancing the Cosmic Dance he's called
Shiva Nataraja.

Hanuman
Chief of the monkeys and Rama's loyal
lieutenant.

Ganesh
Friendly elephant god.

Durgha
Hindu fertility goddess, often shown in many-
armed, militant form.

Yakshi
Shapely female nature deity.

Nirvana
State of supreme liberation or bliss in both
Hindu and Buddhist religions, in which the
soul is released from the eternal cycle of death
and rebirth. Also a rock group from Seattle.

Hinduism's artistic heritage is greatest in India. According to the *Bhagavad gita,* a religious poem from 200 B.C., the world is Vishnu's dream; he sleeps on the coils of Ananta, the endless nine-headed serpent, with his wife, Lakshmi. Vishnu is preserver of the universe; Brahma is its creator, and Siva its destroyer. The cult of Vishnu's avatar Krishna is now most popular in India, particularly in airports. One of the most sacred objects in Hindu temples is the stone lingam, or phallus, which is often preserved in a special inner shrine. This practice may have originated in prehistoric fertility cults.

The fantastic aspect of Indian art can be seen in the statue *Yogini on an Owl,* an eleventh-century Hindu work now in the San Antonio Museum (see fig. 3.2). This voluptuous goddess comes from a rural temple in north India and is an icon of an esoteric cult whose rites included practices offensive to mainstream Hinduism, such as drinking wine, eating flesh (human included), and engaging in sexual intercourse leading to the acquisition of occult powers. This Yogini's front hands point to her mouth with its neatly detailed teeth, while her rear arms grasp a sword and shield. She wears an elaborate pearl-encrusted headdress, rests her feet on lotus flowers, and is flanked by small devotees and celestial garland bearers.

No civilization in the world has given more prominence to overt eroticism than India. Central to this attention is the *Kama Sutra,* a handbook of art of love, written in Sanskrit between the fourth and seventh centuries A.D. Ecstatic figures depicting the *Kama Sutra* can be seen on temples at Bhuvanesvar (A.D. 700), Khajuraho (c. A.D. 1000), and Konarak (c. A.D. 1200). Voluptuousness and sensuality are central to Indian art, whether expressed through swelling flesh or rich ornamentation, not to

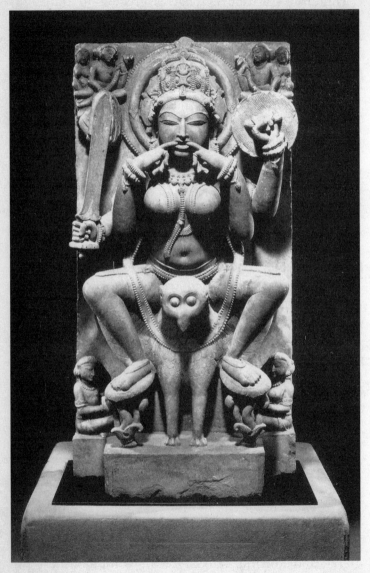

3.2 *This sandstone sculpture of* Yogini on an Owl *was made at Kannauj in Uttar Pradesh in the eleventh century.*

mention enough arms to peel three hard-boiled eggs at once. Even though almost exclusively religious, Indian art always emphasizes sinuous curves as if derived from the provocatively swaying Indian body. In Tibetan art, the Hevajras and Herukalas, locked in sexual embrace, signal not copulation but the marriage in the worshiper's heart of compassion (represented by the male figure) and wisdom (represented by the female figure).

India fell under Muslim rule from 1526 to 1857 (when the British took over). The Muslims were particularly good at making illustrated manuscripts of literary and historical works, often with forms derived from Islamic and Persian art. Mughal painting was brightly colored and highly finished, depicting naturalistic renderings of figures within formulaic compositions.

ISLAMIC ART

In A.D. 630 the prophet Mohammad conquered Mecca and founded the Islamic empire, which eventually stretched from Spain throughout the Middle East to parts of India. Islamic art, which thrived from the seventh to the seventeenth centuries, is unique because of its taboo on images of living religious figures. Hence, we have an art of incredible decorative fluency, ranging from ornate Arabic calligraphy to endlessly repeated geometric motifs and floral arabesques.

But no people. Not even Mohammad. Instead of depicting events, Islamic art emphasizes the fervent expression of religious devotion through elaborate manuscripts of the Koran and other books. Islamic architecture, with its distinctive pointed domes and minarets, is also decorated with carpets, tiles, friezes, carved stucco and metalwork.

AFRICAN AND MESO-AMERICAN ART

It might look primitive to us, but the art of Africa and early Meso-America (the region extending from Guatemala to Mexico) reflects complex societies with richly detailed cultures. They had an unbelievably good eye for style and an ability to create ceremonial objects that seem infused with fierce magic and power that can only be called, well, *primitive*. Both the African and Meso-American cultures were overrun and virtually wiped out by Europeans.

African Art Before Picasso

African art usually refers to the traditional art created by peoples living south of the Sahara, largely on the Niger and Congo rivers. Although practices varied from tribe to tribe, professional artists were usually employed by the chief or king to celebrate his rule. Sculpture made of wood is the most characteristic art, carved with an adze and whittled with a knife, then smoked or rubbed with clay or oil to create the desired finish. Decorative carving was also important. Primitive tools didn't mean crude technique. African artists were superb craftsmen.

One big problem is that the vast majority of African 'art was made from wood, which doesn't last long in a humid climate. Oops, poor planning. As a result, little African art over 150 years old has survived. However some bronze and carved ivory sculptures have survived from earlier centuries.

African artists also worked in stone, bronze, pounded gold, tin, pottery, raffia, wicker, and mud. With the exception of body painting and some rock painting by

AFRICAN AFFILIATES

Some of the leading tribes and their trademark art:

Yoruba (Nigeria). A rich kingdom with court artists who developed a highly naturalistic portrait sculpture. Also made equestrian pieces and stools supported by rings of interlocking figures, and decorated the house posts that held up their roofs.

Benin (Nigeria). Commemorative life-size heads representing spirits of ancestral kings. Learned lost-wax metal casting in the thirteenth century.

Nok (Nigeria). Terra-cotta heads, the earliest yet found in Africa, c. 500–200 B.C.

Dogon (Central Mali). Horned masks with rectangular eye openings and painted with triangular patterns.

Bambara (West Mali). Graceful antelope mask-head-pieces made to invoke favors from fertility spirits.

Baule (Ivory Coast). Ancestor figures with scarification marks.

Ashanti (Ghana). A rich mining tribe along the Gold Coast that made cast brass weights of human and animal figures used to weigh gold dust. Also known for a fertility doll called the *akua'ba.*

Cameroon (Cameroons). Brightly colored sculpted wood masks, plus full figures in dramatic movement. Pipes, ornaments, and house posts were also made by the grassland people of the Cameroons.

Batenke (West Congo). Crested fetish figures with abdominal cavities holding magic charms.

Bushongo-Bakuba (Central Congo). Figure portraits of kings, *bombo* masks modeled on the form of Pygmy

AFRICAN AFFILIATES *(continued)*
. .
skulls, cups in the form of human heads, three-foot-tall
incised drums.

Baluba (East Congo). Ancestor figures with long torsos
and squat legs, and carved stools supported by
caryatids.

bushmen in Southern Africa, no African painting has
survived. The African people didn't have the potter's
wheel and didn't make much pottery.

The social structure of the African tribe consisted of
an extended family grouping conscious of its separation
from others. Art and ceremony was an important source
of this self-identity and embodied the values and beliefs
of the tribe. African art was traditional in the sense that
it was part of an inherited pattern of life.

Art was made to worship ancestors and spirits, to peti-
tion deities for a good harvest or for fertility, to seek
protection from evil, and for initiations into secret socie-
ties. Elaborate masks were made for rituals. Portraits
were also made for kings and, along with other decora-
tive furnishings and objects, were collected for their aes-
thetic value, just as in the drawing rooms of Europe. A
range of art objects was made for trade with Western
colonists and merchants.

The long and complex history of African art can be
traced back to the fourth century in ancient Ghana on
the Niger River in what is now Mali. The Songhai empire
of Gao flourished from the seventh century until the
arrival of the Europeans in the fifteenth century. The

Bantu peoples, a culture based on cattle-owning, can also be dated back to the first century A.D.

Unfortunately for the native Africans (not to mention the elephants), the availability of ivory is one of the main factors that led to the opening up of the continent by Arab and European travelers. Beginning with the Portuguese explorations in the 1500s, European countries plundered their weaker African brothers for gold, ivory, and slaves.

Standing with arms akimbo like a wrestler, the *Kongo Power Figure* from Zaire (c. 1875–1900) (see fig. 3.3) is the very image of power. Its eyes are focused far off to see the spirit world. Each nail represents an oath, a judgment, or a promise. Their power was activated when a nail or piece of metal was driven into the figure.

Around 1905 African art moved to Paris. African sculpture made a big impact on modern European and American art, bringing a new vocabulary of form. African art influenced the Cubism of Picasso and Braque, the Expressionism of Kirchner and Nolde, and the art of Vlaminck, Derain, and Modigliani.

American Art Before Columbus

When European explorers accidentally bumped into a couple of large continents due west of their homeland in the late fifteenth century, they were surprised to find the countries inhabited by a variety of remarkably well-developed cultures. In fact, North and South America had been inhabited probably for as long as Europe and Asia and several major civilizations had developed in the Americas quite independently. Native American civilizations created their own languages, writings, architecture,

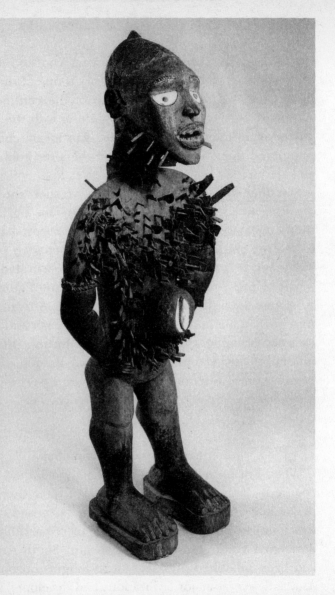

3.3 African art, such as this late-ninteenth century Kongo power figure from present-day Zaire, were made to honor deities or ward off evil.

art, and cookie recipes. Most of these cultures and their remnants were destroyed by European invaders in the sixteenth century and later.

Olmecs

Probably the earliest American civilization that produced art work was the Olmec culture, located in the tropical lowlands of Mexico from about 500 B.C. to about A.D. 1150. Even though the word Olmec means "dweller in the land of rubber," most Olmec works are not made of rubber but are made of basalt, a kind of stone. The largest of these sculptures are 12-foot-high, 20-ton heads of ancient Olmecians wearing some sort of helmets. As a matter of fact, the Olmecs might be considered the original NFL franchise since they championed a sport that was similar to American football.

MESO-AMERICAN CULTURES: A QUICK CHECKLIST
. .
Olmec, 500 B.C.–A.D. 1150. Gulf coast lowlands of Mexico.

Zapotec, 600 B.C.–A.D. 700. Southern Oaxaca province, Teotihuacan.

Mixtec, 700–1300. Southwest Mexico.

Toltec, 850–1250. North and central Mexico.

Aymara, 500–1400. Lake Titicaca basin, Peru, and Bolivia.

Maya, 300–1697. Yucatan, Guatemala, Western Honduras.

Aztec, 1370–1521. Central Mexico; founded Mexico City.

Inca, 1200–1533. Based in Cuzco; Peru; Ecuador to Chile.

One of the principal Olmec sites is La Venta, an island where a series of stone courts, ball fields, and ceremonial arenas were constructed of blocks of marble hauled from 350 miles away. La Venta, which flourished between 800 B.C. and 400 B.C., also features various geometric and effigy mounds in the form of a jaguar (the cat, not the car). Similar effigy mounds were built throughout the midwestern United States at about the same time by a civilization known generally as "the moundbuilders" (catchy), though it is unclear if they were kin to the Olmecs.

Maya

One of the most powerful early American cultures was the Mayan civilization, which reached its height during the period from A.D. 300 to A.D. 900. The Maya were masters of abstract knowledge, noted for their sophisticated calendar, their development of writing and narrative history, and their cultivation of maize. Curiously the Maya did not build cities; they were farmers who grouped their fiefdoms around central temple complexes. In the temples, priests used their very refined calendar to "predict" agricultural cycles.

Mayan figures, sculpted out of clay or hammered gold or silver, were what we would call overdressed—laden with headdresses, earrings, necklaces, feathers, and insignia. The Mayan obsession with decoration can be seen in *Container in the Form of a Diving God* (see fig. 3.4), a late example of a ritual ceramic cup, probably made in the 1400s and now at the Princeton University Art Museum.

Between A.D. 600 and A.D. 900, several cultural centers were established at Copán, Plenque, Uxmal, and other

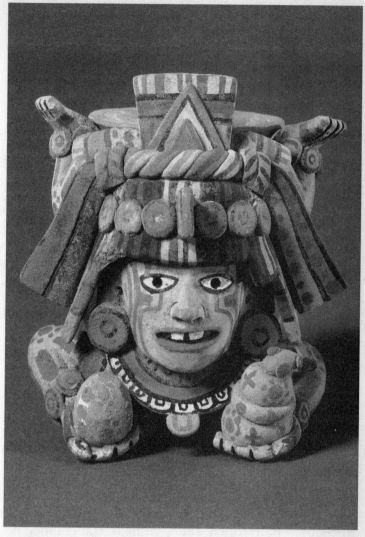

3.4 *Around the time of Columbus, the Maya often made clay figural containers for use in their religious bloodletting ceremonies.*

sites, but were mysteriously abandoned after about a century of use. Today they are big tourist spots. The famous Mayan temples at Tikal were built before A.D. 800 and include steep stepped pyramids and open-air observatories. These buildings are frequently decorated with shallow pictorial reliefs, most notably of priests wearing all manner of strange, plumed headdresses. Some of the reliefs show bloodletting ceremonies and other ritual tortures.

In the tenth century, the Maya were superseded by the Toltecs, a more aggressive people who took over many Mayan sites. In Chichen Itza, for instance, the Toltecs took over the Mayan temples and observatories and adapted them. Especially notable is the round observatory finished around A.D. 1200, or just about the time the cathedrals were being built in Europe. The militaristic Toltecs had their capital at Tula, northeast of Mexico City; it was guarded by fifteen-foot-high figures that look like crudely carved kachina dolls with feather bonnets and propulsion packs on their chests. More subtle was the famous Toltec image of Chacmool, an omnipresent figure that reclines on its back, propped up on its elbows with knees bent, wearing what looks like a space helmet on its head.

Inca

The inscrutable Incas were latecomers, emerging as a culture only around A.D. 1200, expanding rapidly in the fifteenth century, then being virtually extinguished by the Spanish in 1533. Those crazy Incas liked high places and developed their culture way up in the Andes, stretching from Ecuador to the tip of Chile. The capital city of Cuzco was founded around 1200, and from there the

vast empire was connected by a network of roads and towns. Unsurpassed engineers, the Inca built extraordinary palaces, terraces, and cities of interlocking stone on the mountaintops. Most famous is Macchu Picchu (meaning "home of the Incas"), built around 1500 on a steep peak near Cuzco, and discovered virtually intact in 1911.

Incan art is characterized by traditional geometric forms that seem to echo the rigid rectilinearity of their stone block homes. The Inca developed textiles and metalwork, but had no paper. They were skillful at various forms of casting and metallic reliefs, and small gold and silver figures have survived, including many of llamas, the beast of burden indigenous to the Andes. The Inca were skilled but not too inventive, and in general were mountain shut-ins.

Aztec

The Aztec civilization of central Mexico was the last great Meso-American empire. But they really took it on the chin from the Spanish conquistadors. In a way they deserved it, since the Aztecs were themselves conquerors who oppressed the cultures they overran, often appropriating their art forms. Like the Incas, the Aztecs were latecomers, flourishing around 1370 until the Spanish Conquest in 1521.

When the Aztec conquered the highly advanced Toltecs, they took over the city of Tula and much Toltequan culture. But they were barbarians who liked to call themselves Chichimecas, or "sons of the dog." And, like dogs, their religion was based on red meat. Human sacrifice to the god of war, Huitzilopochtli, was deemed essential, and the soldiers of conquered armies often had their

hearts torn from their chests, still beating. (Sounds like a bad Hollywood movie, doesn't it?) Oddly, much Aztec art is based on these sacrificial rituals; there are sacrificial knives, and carved sacrificial altars, and carved stones depicting dismembered goddesses. On the more productive side, the Aztecs also made massive stone calendars and stone pillars depicting gods encrusted with feathers, and are known for a particular type of picture writing that features skulls, hearts, and faces with tongues sticking out.

In 1325, the Aztecs founded their capital city of Teochtitlán, which much later became Mexico City. Over the next two centuries, the Aztec empire expanded rapidly throughout central Mexico. Spanish expeditions led by Hernán Cortés, who had been exploring Mexico since the early sixteenth century, finally reached the Aztec capital in Teochtitlán about 1533. Despite the great military strength of the Aztecs, the Spanish prevailed, destroying the Aztec capital and building on its ruins a European cathedral.

SUMMARY

🕐 **Asian art.** Serene buddhas, ferocious demon warriors, and elegant graphics marked by a calligraphic line and bright colors.

🕐 **Indian art.** Many-armed, voluptuous goddesses, temples densely covered with statuary and ornament, and simple, bright paintings of court life.

🕐 **African art.** Abstract masks and carved figures, plus geometric ornamentation on tools and everyday utensils.

🕐 **Meso-American art.** Great stone heads and blocky stone architecture, plus geometric ornamentation on textiles, tools, and everyday utensils.

OUT OF
THE DARK AGES

YOU MUST REMEMBER THIS

During the Middle Ages—that is, from about A.D. 600 to about A.D. 1350—art and architecture in Europe was devoted almost exclusively to serving the Christian church.

BEST KNOWN FOR

Cathedrals, those soaring monuments to Christianity that took hundreds of years to build and combined architecture, sculpture, engineering, stained glass, and faith.

ART SEES THE LIGHT

After the fall of Rome, the Byzantine Empire ruled the east for more than 1,000 years, dating from the founding of Constantinople in 330 to the fall of the city to the Moslems in 1453. Byzantine art is noted for crude but emotionally powerful icons—renderings of Christ, saints, and the Madonna and Child. The figure was not pictured for its own sake, as in Classical Greek art. Instead, the human body was merely the earthly vessel for spiritual faith. The most typical Byzantine image is of an ascetic saint with hollow cheeks and a dramatic expression.

In the West, we tend to know Byzantine art best as it influenced the art of Italy. Byzantine artisans were masters of the technique of mosaic, in which pieces of colored glass, marble, and other substances were pressed into wet cement walls. Chapels in Ravenna and Padua are famous for their mosaics depicting scenes from the Bible, like the flight into Egypt and the Good Shepherd.

WHAT'S DARK
ABOUT THE DARK AGES?

After the fall of the Roman Empire, and in the midst of a growing schism between the Catholic and Orthodox faiths, the main force of European culture shifted from the Mediterranean countries to England and Northern Europe. Around A.D. 650, vast changes in population centers and political alliances led to the beginning of an eight-hundred-year period that, because of its Christian fervor, might be called "the Age of Faith." In the past, this epoch was often called the Middle Ages, because

**WHO'S
H
O**
☞

Nobody knows the names of the artists, who created not for their own fame but as a kind of worship for the glory of God. Oh yeah, and for the glory of the guys that ran things—the popes and kings.

Byzantine. (c. 330–1450)
The foundation of the Middle Ages was laid during Constantine's rule (306–37), which forged a new Christian art of mosaics, ivories, and miniatures in the East, headquartered at Constantinople.

Carolingian. (c. 800–870)
Art made during the reign of Charlemagne (768–814) and his successors that took as its model the art of what was then considered classical Rome (i.e., the fourth and fifth centuries).

Romanesque (c. 1000–1175).
The first truly international style came from the Church, whose monasteries and churches are marked by barrel vaults, striped facades, and rugged, symbolic religious sculptures and ornament.

Gothic (1100–1300).
Flying buttresses and pointed arches, stained-glass windows, and illuminated manuscripts.

people thought nothing much happened in the period
between the Roman Empire and the Renaissance. But
the phrase *Middle Ages,* like the *Dark Ages,* is a misnomer.
These ages weren't middle or dark or even dim. On the
contrary, this period was extremely exciting, especially if
you were a monk, because the happening thing was
religion.

Between A.D. 400 and A.D. 750, most of what is now
Europe was pagan country, ruled by roving tribes. This
was known as the Migration Period. In the North, in
Scandinavia, were the Goths and the Vikings, known for
their splendid ship carvings. To the East were Germanic
tribes called the Huns, known for their "animal style,"
a flat, highly stylized way of depicting animals and hu-
mans. And to the far West, on the tiny island of Ireland
were the Celts, a tribe of barbarians converted to Chris-
tianity in the fifth century.

For Christians in bleak, windswept Ireland, reclusive
monasteries were the principal centers of learning and
teaching. Monasteries were responsible for the cultural
production of the "Golden Age of Ireland," from A.D.
600 to A.D. 800, a period distinguished by the remarkable
flowering of Celtic art, including patterned metalwork,
large stone crosses, and manuscript illumination (lus-
ciously colored book illustration). Since there were no
printed books, each Bible or Gospel Book (there were
no novels) had to be hand-copied on individual leaves
of parchment in a vast monastery assembly line known
as the scriptorium. Although the monks cranked out
plenty of books, they regarded the word of God as sa-
cred, so each text was treated with reverence and orna-
mented with paintings, gold leaf, and doodles in the
margins.

In Hiberno-Saxon (Irish or English) illuminated manuscripts such as the *Book of Kells* (c. 780) (see fig. 4.1), flat, abstract patterning was the order of the day. Some pages, called carpet pages, consist of nothing but elaborate interlace embellishments on cross shapes or the Chi-Rho symbol for Christ. Separate pages for each of the Evangelists feature abstracted versions of their animal symbols depicted as flat forms surrounded by intertwined linear patterns and geometric decorations that crowd every inch of space.

HAIL, CHARLEMAGNE!

The weird mix of Christianity and Roman paganism that percolated throughout Europe during the Migration Period reached its climax in 800 with the Pope's coronation of Charlemagne (Charles the Great), king of the Franks, as the first Holy Roman Emperor. An egghead, Charlemagne set out to transform the culture of his empire; after him, the period was called Carolingian. At his capital in Aachen, Charles surrounded himself with poets and grad students, and in the lands under his control he established monasteries that specialized in copying, word for word, the classics of ancient Roman literature, as well as the Christian gospels. King Chuck personally inspected ancient monuments in Rome, and ordered hometown copies made of Roman churches, or basilicas. This Roman revival combined Mediterranean classical culture with the rough Celtic Christianity of the British Isles: it was known as the Carolingian Revival.

Most Carolingian art has disappeared, as over the years Charlemagne's churches were restored or rebuilt, with

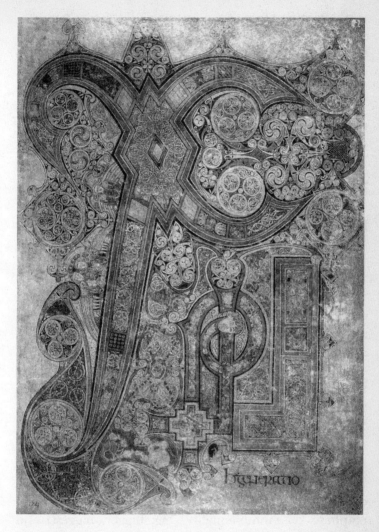

4.1 *Eighth-century monks in Ireland spent a lot of time listening to chants and making doodles in their books. Manuscript page from the* Book of Kells.

the consequent loss of the vast murals, frescoes, mosaics, and relief sculptures that once decorated them. What has survived, in addition to the churches themselves, are carved ivories, goldsmiths' work, and illuminated manuscripts. Although produced only a few decades after the *Book of Kells,* the manuscript illuminations of the Carolingian period rely on completely different principals of composition. Instead of carpet pages with an overall, two-dimensional, graphic design, Carolingian manuscript pages often show little portraits of the Evangelists or scenes set within frames, much like Roman wall paintings.

OTTO'S TURN

Perhaps Charlemagne's rule was too much of a good thing, like too much champagne and caviar. He died after only fourteen years at the helm of the Empire, and his property was divided among his feuding grandsons. They were disorganized and getting beat up by invaders from all sides: the Moslems to the South, the Magyars to the East, and the Vikings to the North. What a mess! Only the Ottonian rulers (named for Otto I) who ruled Germany from 900 to 1024 could get a grip and they sought to extend Charlemagne's cultural works.

The main contribution of the Ottonian period was a consolidation of architectural principles. There was an emphasis on monumentality (big, bigger, biggest) and on clear geometric organization (so that a viewer could "read" a church as an arrangement of cubes, cylinders, and cones). These buildings have massive stone walls, hexagonal towers, and teeny little windows.

DOING AS THE ROMANS DID

Everyone breathed a sigh of relief when the world didn't explode at the millennium. So, not surprisingly, after the year 1000, churches and chapels began to spring up everywhere. Whew, thank God we're alive! By this time, Christianity had spread to every last dale and hamlet in Europe. Even those crazy Vikings had become Christians. And what a sight they made in church. Well, not everyone wanted Vikings in *their* church, so that was another reason more churches had to be built: separate denominations. All in all, more churches were built between 1050 and 1200 than ever before, and probably since. One monk called it a "white mantle of churches" blanketing Europe.

Medieval art and architecture from this period is generally called *Romanesque,* partly because it draws on Roman models and partly because Mediterranean culture itself was rejuvenated. Plus, later critics didn't know what else to call it; compared to Gothic art it was simply more Romanlike. This style sprang up throughout Europe almost simultaneously, breaking out in little regional styles that shared certain common characteristics. In architecture, this meant larger churches (both in size and height) with better lighting (bigger windows) and better circulation inside (more aisles and an ambulatory to go around behind the altar). After all, they had more customers. These churches transformed the Romanlike basilica of the Carolingian period and substituted stone-arch vaulting for those out-of-date flat wooden roofs— the sure sign of a fire trap. Romanesque churches throughout Europe stressed a high degree of geometric

clarity, with regularly spaced columns and pilasters, symmetrical towers, and a complex cross-shaped plan.

The best known of the Romanesque churches were the so-called Pilgrimage Road type, way stations along the hundreds of miles of southern French roads leading to the chief medieval pilgrimage site, the Disneyworld of medieval religious zealots, Santiago de Compestela in northern Spain. Medieval vagabonds, wearing the omnipresent shell badge of pilgrims, walked the whole holy way—some crawling the last few miles on their knees. On the road, churches were key sites, serving as both diners and youth hostels. In design, these churches were somewhat squat and blocky, with rounded rather than pointed features. They used barrel vaults and had little clerestory (upper level) lighting so they were pretty dark and cool; and they featured a wide transcept (the arms of the cross-shaped plan) and often a big tower at the crossing.

One major innovation of the Romanesque churches was the application of sculptural decoration to the facade, or entrance side. It's as if suddenly people remembered architectural sculpture and put it everywhere: on the door jambs (the part around the door), in the tympanum (the arch above the door), on the splays (the walls flanking the doors), and even on the trumeau (the little post between the doors). The carved and painted stone sculpture on early Romanesque churches told biblical stories to the largely illiterate congregation. These stories had a moral lesson: namely, fear God, for the Judgment Day is coming. But this was often told through a somewhat chaotic collection of religious themes. But in later instances, such as the abbey at Moissac, near Toulouse, or at the cathedral at Autun, in Burgundy,

elaborate philosophical programs, attributable to a shop governed by a great master carver, were worked out. Yet, these scenes still revolved around the Last Judgment— often presented as a terrifying, sci-fi scenario of damned souls being gnashed in the jaws of Hell.

In these sculptures from southwest France, importance was indicated by relative size, and the delineation of form was often abstract, based on manuscript illumination. The emotional and symbolic impact on the viewer was placed before observational realism. Figures were elongated, with almond-shaped bug eyes and striated hair. Clothes rarely indicated much of a body underneath, but were composed of abstracted folds and loops. Because the figures had to conform to architectural blocks, there were also some strangely elongated figures or contorted, impossible-to-replicate poses, like Twister in stone.

NOTHING TO DO WITH THE GOTHS

Gothic means quite literally the style of the Goths, the barbarian hordes that destroyed the Roman Empire. Actually, it has nothing to do with the Goths. But that's how Giorgio Vasari and other classicists of the Renaissance thought of the art that preceded them: crude and barbaric.

We're more sophisticated now, though, and we see Gothic art for what it is: church building. Gothic was, after all, a style rooted in architecture; art was basically subordinated to the task of embellishing the house of God. Architecture was particularly important in the 100-mile radius around Paris, the so-called Île-de-France, from 1150 to 1250. This period is known as the "Age of

the Great Cathedrals" and marked the high point of the Church's influence as an art patron.

The essence of the Gothic style is related to the un-fathomable mystery of transcendental meaning. This was the spiritual message the church fathers meant to convey with the uncanny symbolism of the cathedrals. But the ambitious Gothic building campaigns also reflected the new influence of France's towns as centers of trade and culture. The cathedral, the most significant cultural con-tribution of medieval art, was a perfect cumulative em-bodiment of urban wealth, skill, planning, organization, intellectual development, and worldliness. In addition, of course, cathedrals were status symbols erected by com-petitive religious communities.

Perhaps the most obvious aspect of the medieval ca-thedral is its tremendous height. The vaults in Amiens Cathedral are about 150 feet high, as tall as a twenty-story building. Considering the fact that three-story buildings were pretty rare in thirteenth-century towns, cathedrals were like skyscrapers. Height was accentuated because of its religious significance: reaching closer to the heavens. Light also symbolized God, so walls were out and windows were in. Of course, this presented an engineering problem: high walls and lots of windows don't mix, especially if you don't have steel I-beams. So flying buttresses were invented. These were series of exte-rior struts connecting the roofline to pillars ringing the church; they transferred the weight of the roof outward from the walls. Inside, pointed arches and ribbed vaults also helped to shift weight from the roof to supporting columns and pillars.

The removal of the load-bearing function from the

GO TO CHURCH:
A GUIDE TO FRENCH CATHEDRALS

If your parents took you to Europe when you were a kid, they probably dragged you around to church after church. One reason you had to go to so many is that each one is different. No kidding. And some of them took hundreds of years to build. Which was kind of a drag because they would begin on the east end with a nice sober Romanesque style and by the time they got to the western facade, a century later, styles had changed and they were into some fancy Gothic thing. Anyway, here's a quick tour of the major sites in the Île-de-France:

Abbey Church of St. Denis, near Paris (1140–44).
Abbot Suger's church, where it all began; emphasis on light and decoration.

Notre-Dame, Paris (1163–1250).
Noted for its rose windows, flying buttresses seen from the Seine, and, of course, gargoyles.

Chartres Cathedral (1194–1220).
The most perfectly preserved ensemble of High Gothic sculpture, stained glass, and architecture.

Reims Cathedral (1225–99).
Serialized by Monet; vertical, with projecting porches and elegant sculptures in every nook and cranny.

Amiens Cathedral (1220–36).
Called the purest example of Gothic architecture; plan and facade are logical and harmonious.

Bourges Cathedral (1195–1255).
Late Gothic; lots of light.

walls allowed for an increase in the amount of glass windows. This quickly expanded the possibilities for stained glass, a method of creating images by assembling small bits of colored glass within a lead frame. Mostly the representations were created by the shape and cut of the glass, but later fine details were also created by painting on the glass. The images were two-dimensional in the manner of manuscript illumination but they appeared enlivened by the constant play of shifting light through them. Rose windows, such as at Notre Dame in Paris, were large circular stained-glass windows, often over the entrance. The high point of stained-glass production was about 1200 to 1250.

Architectural sculpture was the other great achievement of the French High Gothic period. On the facades of the great Gothic cathedrals, church scholars planned extensive, even encyclopedic, depictions of saints, apostles, martyrs, and other heroes of church history. Narrative scenes in carved stone crowded the panels and arches above the doors. The West Portals of Chartres Cathedral (c. 1145–70) (see fig. 4.2) represent the high point of Gothic sculptural decoration. The whole facade, as shown here, is distinguished by a remarkable clarity of design and organization. Gone are the frantic contortions and mixed up narrative sequences of Romanesque art. Instead, each sculpture is given its own place in the harmonious and logical scheme. Column figures flanking the doors are almost three-dimensional, free-standing sculptures, although they are radically distorted to fit the elongated columns and to direct the viewer's eye upward. Above are the biblical stories, showing the birth, presentation, and early life of Christ. Over the center portal is Christ enthroned. Other sculptural details,

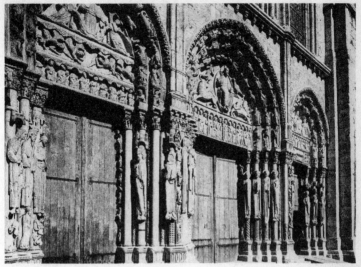

4.2 *Medieval viewers (c. 1145–70) would have gotten an elaborate lesson in history and religion just by looking at the West Portals of Chartres Cathedral, not far from Paris.*

filling every available space, represent the signs of the zodiac, the labors of the month, and occasionally the signatures or marks of the carvers themselves.

In the Late Gothic period, from about 1330 to about 1450, ornament overcame clarity, cathedrals became encrusted with elaborate stone tracery, painted details, crested finials (a little ornamental knob, usually decorated with plant shapes), and miscellaneous sculptural doodads. Sometimes these Late Gothic churches, in the so-called Flamboyant Style, are so elaborate that they looked like walk-in jewel cases. In smaller chapels, such as the Sainte Chapelle in Paris (1243–48), this preciousness creates a kind of claustrophobia. It's just too damn fussy. And, although painting on panels was un-

common in the North, the few paintings that survive show a similar obsession with detail and ornamentation. The Renaissance was a welcome relief.

PAINTING AND SCULPTURE: BARELY HANGING ON

At the end of the thirteenth century, painting on walls and on panels began to assume an increasing importance among the means of ecclesiastical decoration. In Italy, in particular, because of influences from Greece

THE DAWN OF THE RENAISSANCE

Before the Renaissance was in full swing, a few Italian artists were laying its foundations. Some of the leading figures:

Duccio di Buoninsegna (1250?–1319?).
First Sienese master, known for soft drapery and graceful faces, who painted the Maesta altarpiece in the Siena cathedral.

Cimabue (1240?–1302?).
First famous Florentine painter who worked in the Byzantine style. Only a few works survive today, notably the *Madonna and Child with Angels* in the Uffizi Gallery in Florence and the frescoes and crucifixion in the church of St. Francis at Assisi. Dante dissed him in the *Divine Comedy,* noting that he was out and Giotto, more of a realist, was in.

Nicola Pisano (1210?–1278?).
Gothic sculptor in Italy, a forerunner of the Italian Renaissance who spent most of his life in Tuscany. He made pulpits for cathedrals at Pisa and Siena, modeled after Roman sarcophagi.

and old Byzantium, panel painting was popular. Byzantine painting affected both the medium and the style of Italian Gothic painting. Figures are often tall and slender, they inhabit a schematic space determined by the architecture, and the sky and background are often a uniform gold. But—and this is an important difference—in the works of artists like Duccio and Cimabue, there is a new attention to the details of individual behavior, as in the description of gesture and response. Sculptors also began to combine the Byzantine styles, more abstract and schematic, with a new, classical sense of the human body as both capable of moving through space and of feeling emotion.

SUMMARY

In the Middle Ages, art existed to serve Christianity, in a sumptuous and stylized way, using lots of gold, bright colors, and precious materials.

The greatest achievements of medieval culture were the cathedrals, assembled over decades by generations of anonymous craftsmen.

Finely crafted objects like tapestries, ivories, and illuminated manuscripts were made for royal patrons.

RENAISSANCE PLUS

YOU MUST REMEMBER THIS

Fidelity to nature and the search for perfect form were the main goals for artists in the Renaissance, who copied the pagan Greeks, though the topic of the day remained religion.

BEST KNOWN FOR

The Renaissance produced all those great masterpieces that are the destination of every European vacation and the subject of countless postcards home: Leonardo da Vinci's *Mona Lisa* and *Last Supper*, Michelangelo's *David* and the Sistine Chapel, Raphael's *School of Athens*.

WHAT IS THE RENAISSANCE?

W hat's a French word doing describing something that happened basically in Italy? That's right, it was a French writer, historian Jules Michelet, who named the Renaissance—well after the fact. In the 1800s, everyone decided that learning had ended at the fall of the Roman Empire and only began again after the so-called Dark Ages, around 1200. They called the new period the *Renaissance,* meaning rebirth.

EARLY RENAISSANCE IN ITALY

The Renaissance marked the rebirth of classicism and the recovery of classical culture of Greek and Rome. Religious subject matter and patronage began to decline. The church was no longer the only patron of art; suddenly princes like Lorenzo de Medici were also buying art works and supporting poets and scholars. These new patrons also encouraged the philosophy of humanism, which made man, not God, the center of reference. The Renaissance was time of dramatic social changes, including the invention of gunpowder, the rise of cities, the invention of the printing press, voyages of discovery, the end of feudalism, the beginning of freethinking and the Reformation, and the origins of modern science. For artists trying to copy nature, science meant a close look at anatomy—not only drawing from the model but also making dissections (and we're not talking about frogs).

Artists attempted to represent the world by understanding its structure. Early Renaissance artists in Florence and Rome, in particular, tried to depict people in

more realistic, three-dimensional form. They tried to depict architecture in ways that recreated illusionistic depth through mathematical perspective. This marked a turn from the more decorative or purely schematic depictions

WHO'S WHO ☞

The Renaissance had dozens of artists of note, but the Big Three of art's old-boy club are:

Leonardo da Vinci (1452–1519).
Inventor, engineer, artist, and scientist, Leonardo was born in the little town of Vinci (duh). A true Renaissance man, Leonardo studied human anatomy and water movements, designed cannons and fortifications, and made really nice paintings and sculpture in his spare time.

Michelangelo (1475–1564).
Among his extraordinarily lifelike marble sculptures of the human body are his eighteen-foot *David,* as well as the marble *Pietà,* now in Saint Peter's Church in Rome. Despite being a sculptor, he was commissioned to paint the Sistine Chapel ceiling in the Vatican. He did it while lying on his back.

Raphael (1483–1520).
A child prodigy, at first he worked in Florence painting tranquil Madonnas. Later he went to Rome, where he painted frescoes in the Vatican, including *Parnassus* and *The School of Athens.* Called The Divine Raphael.

of the High Gothic period, or International Style, as it was known in Italy.

Along with a fascination for mathematics and science, Renaissance artists were motivated by the idea of progress. To them, the artist was like a scientist; that is, a painter or sculptor made art not just to satisfy himself, his customers or the public, but to experiment with solutions to problems as well. The aim was to systematize knowledge: to make a science of painting, to turn medicine into an art. Classicism was, in their minds, the perfect and inevitable solution to any given problem. In other words, art was like a puzzle, and true art articulated order.

The biggest selling items during this period remained devotional images of the Holy Family, Adam and Eve, assorted saints, and scenes from the Bible. Only later did Renaissance artists begin to draw on the entire range of mythological and social subjects for their works. Some of the major artists of the Early Renaissance:

Giotto (c. 1266–1337). Launched the Italian Renaissance by painting people who appeared three-dimensional rather than flat. Painted famous fresco cycles in Padua, Florence, and Assisi.

Masaccio (1401–28). Florentine painter who really mastered sculptural form, perspective, and figure groups in fresco. The most advanced artist of his day, Masaccio died young.

Ghiberti (1378–1455). Florentine sculptor and goldsmith who spent twenty-one years making a pair of doors with twenty-eight intricate bronze panels for the Baptistery in Florence. A second set of doors, called *The Gates of Paradise,* took him even longer.

Donatello (1386–1466). Florentine sculptor of uncom-

mon grace, invented relief sculpture. Best known for his heroic *St. George* (1408) and his sexy nude statue of *David* (1425).

Filippo Brunelleschi (1377?–1446). Architect who figured out how to build the Cathedral of Florence's dome, then the largest in the world. Also, first to apply rules of perspective to art.

PERSPECTIVE, OR WHY'S THAT GUY IN THE BACKGROUND SO SMALL?

Perspective (also called scientific or linear perspective) is nothing more than a mathematical system for representing three-dimensional objects on a two-dimensional surface. This requires a single, fixed viewpoint and a distant vanishing point on the horizon—you've seen those diagrams of the railroads tracks extending toward the horizon. Given this diagram, the relative heights and distances of all objects and spaces can be calculated so precisely that any view can be plotted on a floor plan. Brunelleschi was the first to apply perspective to painting and architecture, although the greatest master of perspective was Piero della Francesca (c. 1420–92). Piero worked out a way of drawing all things—heads, hands, drapery—so they look like solid geometric forms seen in precise mathematical perspective. It was art in 3-D, without the glasses! This optical illusion gives his paintings a clarity and rationality, but makes his figures look like blockheads and coneheads.

HIGH RENAISSANCE IN ITALY

One of the most important High Renaissance artists in Florence was Sandro Botticelli (1444–1510). A painter, Botticelli was known for his sensuous love for the human

form—you could say he's the real father of Barbie. Most famous for the lyrical *Birth of Venus* (a.k.a., Venus on the half shell) and the *Primavera* (or *Birth of Spring*), he also did many frescoes and religious paintings, especially at the end of his life after falling under the sway of ascetic Florentine preacher Savonarola.

The other major artists in Florence were Leonardo da Vinci and Michelangelo. Leonardo was a jack-of-all-trades who insisted on the dignity of painting, its status as one of the liberal arts, and its quality as an activity of the mind. What concerned him was art's capacity to invent, not execute. This insistence on invention at the expense of craftsmanship tended to distract him from painting. A master craftsman as well as a classic daydreamer, Leonardo saw drawing as a vehicle for the poet's imagination. He wrote: "I have even seen shapes in clouds and on patchy walls which have roused me to beautiful inventions of various things, and even though such shapes totally lack finish in any single part they were yet not devoid of perfection in their gestures or other movements."

Leonardo
da Vinci
(1452–1519)

Although a Florentine, Leonardo made few of his famous works there. Instead, he took freelance jobs all over the place, not only painting portraits but also building forts, diverting rivers, and developing court entertainments. Of course, he continued to paint portraits, his bread-and-butter work—that's what led to the famous *Mona Lisa* job. Even in the early portrait *Ginevra de' Benci* from 1474 (see fig. 5.1), the 22-year-old Leonardo produced a portrait that captured the mystery and charm of his sitter. It is a rather simple and elegant portrait, but note the sophisticated modeling of her face using shadowing (or, as the Italians say, *chiaroscuro*) and the intense mood of melancholia. Art historians regard this as the first psychological portrait ever painted. The work came to the National Gallery of Art in 1967 from Vienna and is the only work by the artist in a U.S. museum.

In Milan, Leonardo was commissioned by the friars of the church of Santa Maris delle Grazie to create a fresco for their main dining hall. This became the monumental *Last Supper* (1495–98). You've all seen this one in countless reproductions, postcards, and illuminated plastic replicas. Well, now it might seem banal, but when it was first unveiled it was astonishing because of the distinctive psychological character Leonardo had given to each of Christ's dinner guests. They were so realistic, it was as if they were actually sitting in the room with the viewer. Unfortunately, when the church later moved its eatery, someone cut a big door through the painting. Oops.

It was also in Milan that Leonardo painted the fashion-

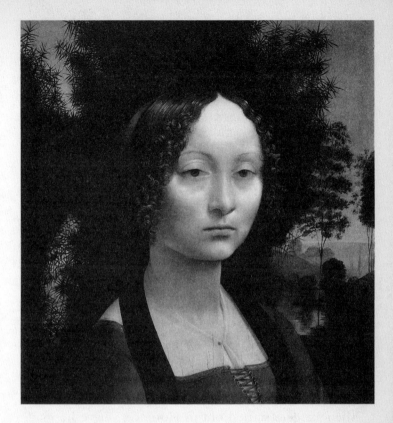

5.1 *Several years before his* Mona Lisa, *Leonardo da Vinci painted the equally lovely, but smileless,* Ginevra de' Benci *(1474), a work now in the National Gallery in Washington, D.C.*

able *Mona Lisa* (1507), a conventional upper-class portrait made special by the sitter's enigmatic smile. It is now in the Louvre in Paris. The subject is thought to be the 24-year-old second wife of an obscure citizen of Florence, Francesco del Giocondo—thus the painting is also referred to as *La Gioconda.* The Italian artist and

biographer Giorgio Vasari (1511–74) wrote that Leonardo employed musicians and jesters to entertain the melancholy sitter. In the work Leonardo is credited with developing the painting technique called *sfumato* (Italian for "like smoke"), in which different areas of color and form were subtly merged together, "like smoke dissolving into the air," as one Renaissance artist put it.

WHEN IN ROME . . .

Although Florence was the happening place in the fifteenth century, after about 1490, the art scene shifted to Rome. Throughout the sixteenth century, Rome remained the center of artistic and philosophical activities. In part because of the rise of Pope Julius II, a prominent art patron, the Vatican drew many great artists to Rome. Julius oversaw the rebuilding of St. Peter's Cathedral, the redecoration of many of its devotional chapels (including the Sistine Chapel), the development of huge fresco schemes, and the design of his own tomb (he was thinking ahead).

Michelangelo started out in Florence, where he made quite a name for himself as a sculptor. His major Florentine work was the eighteen-foot-tall *David* (1501–4), which, though carved from a single block of stone is highly detailed and animated. The sense of action in Michelangelo's figures and their anatomy was perhaps inspired working side by side with Leonardo on two murals for the Florence city hall which were later destroyed. Michelangelo was finally lured to Rome by Pope Julian who wanted the artist to carve him a massive tomb. Michelangelo worked on it off and on for years and never did finish it, although he made for it an extraordinary statue

of Moses (ca. 1514). While at work on the tomb, Michelangelo was ordered by the still-very-much-alive pope to paint the ceiling of the Sistine Chapel. At first, Michelangelo said, "No way, I'm a sculptor." But the mitre man wouldn't take no for an answer. So Michelangelo painted the entire Sistine ceiling in four years (1508–12) in order to get back to carving his patron's tomb.

Michelangelo was later immortalized in *Vasari's Lives of the Artists* (*Vite de' pittori, scultori ed architetti*), first published in 1550. This great document of the Renaissance promoted the idea of artistic progress and hierarchical genius, with Michelangelo at the pinnacle.

The other darling of the papacy and top gun of the High Renaissance was Raphael (1483–1520)—the painter not the archangel. Raphael was a child prodigy and an orphan who lost his mother at eight and his artist father at eleven. He studied with various masters including Perugino, then moved to Florence, where he painted a lot of tondos (circular paintings). His painting combined the sculptural solidity of Michelangelo with the pictorial inventiveness of Leonardo and added his own unique blend of color, dramatic movement, and sweetness.

At about the time Michelangelo was beginning work on the Sistine ceiling, Raphael was summoned to Rome by the pope to paint frescoes in the hallways of the Vatican. Of these, the greatest are *Parnassus* (1508) and *The School of Athens* (1510–11). One of the freestanding panel paintings made by Raphael in Rome is the circular *Alba Madonna* (1510–11) (see fig. 5.2), now in the National Gallery in Washington. This picture shows the Madonna and Child in an idyllic landscape; their elegantly plotted pyramidal pose illustrates the Renaissance ideal of combining Christian spirituality with a sixteenth-century view

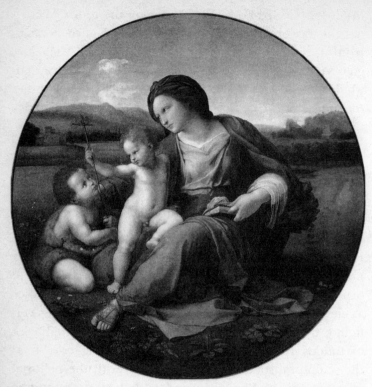

5.2 *A combination of Christian spirituality and Renaissance love of geometric composition marks Raphael's* Alba Madonna, *1510–11.*

of harmonious calm. The painting was owned by the Duchess of Alba in the eighteenth century, thus its name. In 1514, Raphael was appointed chief architect of Saint Peter's. He gained popular ascendancy in the mid-nineteenth century when he became the focus of the Pre-Raphaelites, a Victorian cult of beauty. Scores of Anglos made the pilgrimage to Italy to view painted Madonnas, and Raphael's work became the ideal of academic art theory.

HIGH RENAISSANCE IN VENICE

Unlike Florence and Rome, the Renaissance in Venice developed in a much more gradual way. Venetian artists tended to focus on color and light effects and to emphasize poetic allegories and outdoor picnics rather than vengeful gods or dogmatic religious iconography. Let's just say it was more fun in sunny Venice. Some of the major artists up north were:

Jacopo Bellini (1400–70) was Venice's first Renaissance artist. Most of his paintings are lost, but some

CITIES OF THE RENAISSANCE

In order to understand the Renaissance, a grand tour of Italy (if only imaginary) is a necessity. And you can't tell the players without a scorecard. So here we go. Don't forget that these cities were not all part of one country as they are today, but were competing city-states.

Florence. True home of the Italian Renaissance, where the revolution started. Known for the Duomo (Cathedral) and the Baptistery; the main art museum is the Uffizi, but much of the sculpture is right on the streets. Main Florentine artists: Giotto, Masaccio, Michelangelo (before he went to Rome), Lippi father and son, Botticelli, Brunelleschi, Luca Della Robbia and nephew Andrea, Donatello, and of course Leonardo.

Venice. The city of canals and gondolas also has an extraordinary number of palazzi and churches that needed to be filled up with art. Venetian art is known for its splendorous color. Titian, Venice's greatest painter, bats cleanup; other starters are Tintoretto,

CITIES OF THE RENAISSANCE *(continued)*

Giorgione, and Veronese. Don't forget the Bellini family, Jacopo and his sons Gentile and Giovanni.

Rome. Home of the pope, a big Renaissance patron, and lots of classical ruins. At first, not so important to the cultural shifts of the Renaissance, but of vital importance to the High Renaissance. Raphael is the main man (he's buried in the Pantheon!); but who can overlook Michelangelo's work in the Vatican?

Padua. Venice suburb that was a center of humanist scholarship in the Renaissance. Giotto painted his famous Scrovegni Chapel there; you can also see Donatello's great equestrian statue of Gattemelata.

Urbino. Ruled by Federigo, an important Renaissance prince and arts patron. Commissioned major works for his palace from Raphael and Piero della Francesca.

Parma. Home of Correggio (1494–1534), a painter known for his soft surfaces and intertwined forms.

drawings of the crucifixion and the annunciation survive. His two sons, Gentile Bellini (1429–1507) and Giovanni Bellini (1430–1516), were even more famous than he was, but had nothing to do with the drink of the same name.

Giorgione (1478–1510) was an early Venetian master who is celebrated for being the first artist to merge figures with their backgrounds, largely through proto-Impressionist techniques (brushy rather than smooth paint, mixing colors to make grays). His most famous work was *The Sleeping Venus*. Titian was his follower.

Titian (1477–1576) was the greatest painter of the Venetian Renaissance. He studied with Giovanni Bellini

and Giorgione and painted portraits, altarpieces, and religious, historical and mythological subjects for patrons throughout the royal courts of Europe. He is famous for his *Venus and Adonis* (1560), which is in the National Gallery in Washington. He is also known for the huge

HOW ANGELS GOT THEIR WINGS

Did you realize that the Bible says next to nothing about angels having wings or flying around? The two Old Testament angels who warned Lot about the destruction of Sodom, for instance, looked like ordinary men. In the New Testament, when the angel Gabriel visits Mary to tell her that she will bear the Messiah, nothing is said about flying. But by about A.D. 400, angels really began to spread their wings, so to speak. All the Christian pictures of the Annunciation, the Ascension, and other holy events show God's heavenly servants as winged beings. What gives?

As it turns out, the wings came from pagan Greek art. Christian artists adopted the Greek imagery. Though major Greek gods were wingless (the likes of Zeus, Apollo, and Artemis hardly needed wings to inhabit the heavens), lesser gods required them to fly. Hermes, the messenger between the gods and humans, had wings on his ankles (in fact, *angel* is Greek for "messenger"). Eros, the mischievous winged god of love, transmogrified into the cherubim, part of the rejoicing host of heaven.

But the closest Greek parallel to the angel of Renaissance art is the Winged Victory, which presided over Greek military victories. Of course, the pagan Winged Victory was a next-to-naked female. Christian artists, shunning the carnal appeal of the flesh, made their angels of neutral sex and dressed them up thoroughly in flowing robes.

Rape of Europa at the Isabella Stewart Gardner Museum in Boston. Lived a helluva long time.

Tintoretto (1518–94) is the last of the great Venetian Renaissance painters. He excelled in gorgeous colors and vigorous action. Tintoretto, or "the little dyer" (his father dyed textiles), is known as a Mannerist because he painted from his own imagination rather than from nature. It is said that he made small models in stagelike boxes and painted his scenes from those.

Paolo Veronese (1528–88) closed out the Renaissance in Venice with a very theatrical, very Mannerist style.

THE NORTHERN RENAISSANCE

Three men were the greatest early masters of the Northern Renaissance.

Jan Van Eyck (1380?–1440), another founder of Flemish painting, was responsible for the Ghent Altarpiece (1492). A master of detail, Van Eyck perfected oil painting technique. He did that famous wedding portrait, *The Marriage of Giovanni Arnolfini and Giovanna Cenami* (1434), with the convex mirror in the background.

The Flemish painter Roger Van der Weyden (1399–1464) was known for dignity and observation and obsessive sense of detail. He was headquartered in Brussels, from whence he made portraits of nobles in the court of Duke Philip, in addition to religious pictures.

The Dutch painter Hieronymus Bosch (1450?–1516) was known for fantastic and panoramic landscapes of a medieval world rent by devilish powers. His seemingly drug-induced pictures often show many small, hybrid creatures distributed over a large landscape.

THE HIGH RENAISSANCE
IN THE NORTH

Communications and travel between Italy and Northern Europe were difficult in the fifteenth and early sixteenth centuries. But it has become clear to art historians that there were extensive links between the intellectual and artistic developments that occurred in the two regions. Northern Renaissance painting is often characterized by a great attention to realism and detail, a love of expressive fantasy, and an affinity for everyday scenes.

Among the major artists of the North, the most famous and widely traveled was Albrecht Dürer (1471–1528). Born and educated in Nuremburg, Dürer then traveled to Venice, where he lived for a while. When he got back to Germany he made a big deal of the painting tips he had picked up in Italy. His newly acquired understanding of classical form, the nude body, and scientific perspective made him the first great German painter of the Renaissance. He was also known for his bold woodcuts and exquisite engravings, such as *Adam and Eve* (1504) (see fig. 5.3). In this work, Dürer used the first family as a kind of illustration of the ideal canon of human proportion. He also included many arcane allegorical details, such as the parrot perched on the branch of the Tree of Life, a symbol of the virgin birth of Christ. These clever details, plus Dürer's masterful depictions of various textures in this engraving, made him well known. That went to his head, and ever after he always made self-portraits that depicted him as a genius or as Christ himself.

Pieter Breughel (1525–69) is a Flemish painter known for allegorical landscapes, seasonal panoramas, and

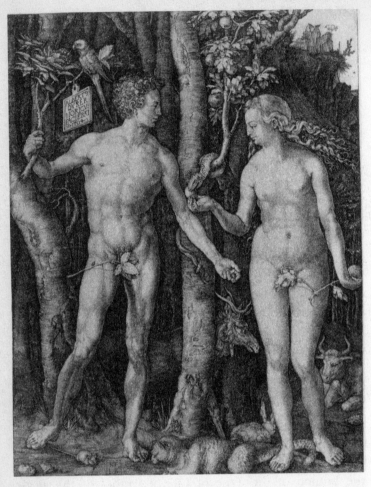

5.3 *Adam and Eve model the latest in Classical proportions in this engraving by Albrecht Dürer, c. 1504.*

earthy parables of peasant life, such as *The Blind Leading the Blind* (1568), *The Wedding Dance* (1566), and *The Return of the Hunters* (1576). Bruegel's *Wedding Dance* uses great detail to show the organized pandemonium of this peasant celebration. Art historians think that Bruegel may have depicted himself in the painting as the quiet, isolated observer to the right behind the bagpipers.

GOING FOR BAROQUE

After the Renaissance, there followed a period of great wealth typified by courtly festivals and the vesting of royal ceremony in garments of classical mythology. In art this secular world was represented through swirling figures, bravura displays of composition, and fantastic compositions of light and dark. Originally the term *barocco*, like the term *gothic*, was used to describe bad or bizarre taste. Later, "gothic" became the word for what was barbaric, while "baroque" became the word for that which was degenerate.

Perhaps the most colorful Baroque master was the mysterious Michelangelo Merisi da Caravaggio (1569–1610), a swashbuckling rogue if there ever was one. He was even tried for murder! A naturalistic painter known for dramatic use of light, Caravaggio settled in Rome and worked in Genoa and southern Italy. He scandalized the church by painting religious subjects in everyday settings with ordinary people. In his painting *The Cardsharps* (1595), Caravaggio introduced the subject of cardplaying—complete with cheating—as an allegory for the game of love. The artist draws you into the game by revealing the secret of the trick. The beautiful but gullible youth just doesn't get it. Caravaggio revolutionized

painting by working directly from life without preparatory drawings.

The Flemish painter Peter Paul Rubens (1577–1640) was also a diplomat and a scholar. He was noted for his brilliant use of color, his imagination, and his ability to create crowds of vigorous figures. He joined the painters' guild, worked for the Duke of Mantua, became court painter to Archduke Albert, and received commissions from the church. His famous 1622 series of pictures of Marie de Medicis, mother of Louis XIII, combine figures from legend with allegory and actual portraits. As a diplomat, he negotiated a temporary peace between Spain and England in 1630. He had a Lolita fixation: he married a 16-year-old, Helene Fourment, when he was 53 and painted a famous portrait of her nude and pleasingly plump in a fur coat. We were born in the wrong age, think many women of today when they view Rubens's ladies, presumably referring to their bountiful rosy flesh rather than their ever-present nakedness.

El Greco (1542–1614) was born Domenikos Theotokopoulos in Crete (hence *El Greco,* the Greek), studied with Titian, and settled in Toledo at age 36. He is known for his mysticism and religious emotionalism, his elongated and twisted figures, and his psychotic colors. His *View of the City of Toledo* (1595) is often called the greatest landscape in the history of art.

Rembrandt Harmensz van Rijn (1606–1669)

Without a doubt the greatest Dutch painter is Rembrandt (1606–69). He is just as famous for his etchings and drawings. His poetic portraits with unusual lighting made ordinary people look mysterious and exotic. His early

5.4 *"Homer, do you read me?" Rembrandt's 1653 painting conjures up the imaginary scene of Aristotle contemplating Homer's bust.*

works, such as *The Night Watch* (1642), stressed drama, action, and contrasts of light and dark. Rembrandt enjoyed painting his friends and family wearing fancy outfits. His *Aristotle Contemplating the Bust of Homer* (1653) (see fig. 5.4) was commissioned by a Sicilian noble and ostensibly shows the greatest of all philosophers thinking about the greatest of all poets. The artist's virtuosity is evident in the masterful treatment of the costume and the lighting, which suggests the inner life of the artist's

subject. His later works, like *The Jewish Bride* (1669) or *The Return of the Prodigal Son* (1669), tended to be calmer and more contemplative. His first wife, Saskia, died young and his fortunes declined as he mourned, until he married his housekeeper, Hendrickje, who set up a shop that employed him to protect his works from his creditors.

Jan Vermeer (1632–75), everyone's favorite painter, showed the everyday life of the prosperous Dutch bourgeoisie through his subtle handling of light effects. In the famous portrait *Girl with Pearl Earring* (1656), light glints off the sitter's jewelry, and in *Young Woman with a Water Jug* (1660), the sun streams in as the young woman opens the window, perhaps to water plants outside the window. Remarkably, only thirty six of his paintings survive.

Velazquez (1599–1660) was born Diego Rodriguez de Silva y Velazquez in Seville in 1599, and he became the greatest Spanish painter of the Renaissance. He first gained notoriety by painting religious pictures in a naturalistic, rather than ideal style. He used this manner to paint humble pictures of still lifes and everyday life scenes, emphasizing textures and details. In 1623, he became the official court painter to King Philip IV of Spain. His paintings from this period were strongly influenced by the works of Venetian painters in the royal collections, including Titian. Several paintings, including the *Rokeby Venus* (1650), were virtual imitations of Titian's work. But mainly he made portraits of members of the court, including court jesters and dwarfs, giving each life and character. His most famous painting, a large late work called *Las Meninas* (or *The Maids of Honor*), shows the king's daughter, the Infanta, and her

dwarf attendants, posing for a portrait by Velasquez. In other words, the portrait we see is the canvas on the easel in the painting! Confusing? Well, that's just the beginning of the hall of mirrors in this painting about painting. The complex work is full of mirrors, shadows, and painted reflections; the king and queen, reflected in a mirror at the rear of the painting, would be standing where we are.

SUMMARY

During the 1400s and 1500s, mainly in Italy, artists rediscovered the harmony and proportion of the art of ancient Greek and Rome.

Linear perspective allowed painters to make two-dimensional images look three-dimensional.

The two principal forms of painting were quite different: fresco painting was large-scale and attached permanently to the wall; panel painting on thin wooden panels was an innovation of the Renaissance and allowed art to be portable.

Private patronage became important and, along with humanist philosophy, encouraged the rise of the individual artist.

ROCOCO TO REALISM

YOU MUST REMEMBER THIS

From the 1700s through the nineteenth century, art starts to do all the stuff it's famous for today. You have art that is full of fun (Rococo), art that builds character (Neoclassicism), art that has soul (Romanticism), and art that tells the truth (Realism).

BEST KNOWN FOR

French art rules. Paris saw a dizzying array of new art movements that paralleled the rise of the modern world. Major movements had major figures:

TIMES THEY ARE A-CHANGIN'

Big changes were afoot in Europe in the eighteenth century. Science was replacing theology. Democracy was replacing divine rule. Kings were getting whacked left and right. Art had to change, too.

Artists had begun creating images of frivolity for the aristocracy. This was the Rococo, essentially a revolution in interior decorating that extended to painting.

But Enlightenment thinkers like Jean-Jacques Rousseau (1712–78) wanted a clear and logical art that could teach lessons of civic virtue. Many artists got caught up in the exciting events of the French Revolution (1789) and the subsequent reign of Napoleon as emperor of France (1804–14). Artists became reporters, reacting directly to current events and celebrating the new political leaders. Both Neoclassicism and Romanticism developed during this period.

Formerly the property of kings, art now belonged to the people. Art served a political purpose: it expressed a national spirit that replaced the former devotion to king and church. Finally, artists began to examine the life of the common people and celebrate it. This was Realism.

ROCOCO: ART OF THE BOUDOIR

Marked by a relaxation of morals and a much lighter touch than the Baroque that came before, the Rococo is probably the only art style that paid serious attention to things like slippers, ribbons, and billets-doux (you know, love notes). Like a lot of art terms, Rococo began as a derisory artist's studio name for the style popular in

the early 1700s in the court of Louis XV. The Rococo is known in general for excessive decoration, ornament, and scrollwork (better known as, curlicues).

One specialty of Rococo painting is its artificiality—in particular, landscapes that look like stage sets for fairy tales. The French landscape painter Hubert Robert (1733–1808), for instance, made a specialty of painting idealized Italian landscapes, many focusing on pictur-

WHO'S WHO

François Boucher (1703–70). Frivolity and artificiality personified, he defines the Rococo. Wouldn't copy nature, calling it "too green and badly lit."

Jacques-Louis David (1748–1825). Mr. Neoclassicism, composed patriotic scenes from Imperial Rome to Napoleon. Very serious.

Jean Auguste Dominique Ingres (1780–1867). Bathers and blue bloods. A student of David's, he became the daddy of academic painting. Invented the odalisque.

Eugène Delacroix (1798–1863). The original Romantic. Made dramatic paintings of shipwrecks, guys falling off horses, and people getting eaten by tigers.

Gustave Courbet (1819–77). The Big Kahuna of Realists, an anarchist revolutionary, he ended up in jail for his political activities and died broke in Switzerland.

esque ruins. Robert sold scads and scads of them to French collectors. During the revolution, he was imprisoned and was going to be sent to the guillotine but another person with the same name was chopped instead! Later Robert became a curator at the Louvre, France's national art museum, and helped design the gardens at Versailles.

The first great Rococo painter was Jean-Antoine Watteau (1684–1721), who rejected the grand subjects of painting, preferring to depict trivial picnics and costume parties instead. Watteau is said to be the first truly Parisian painter, specializing in dainty and mannered scenes of high society. A celebrated colorist, he is credited with being the first to use the technique of divisionism, in which the pure colors are juxtaposed on the picture and blended by the eye rather than being mixed into various tones on the palette. He died at age 37 of consumption.

Jean-Baptiste-Siméon Chardin (1699–1779), the eighteenth century's greatest naturalistic painter, lived through the Rococo period but didn't succumb to its love of make-believe. He painted naturalistic still lifes and sweet little pictures of scenes from the everyday life of the middle class.

François Boucher (1703–70) was the all-around Rococo artist. He made paintings, designed tapestries and porcelains, designed decorative interiors, created stage sets for the opera and ballet, even designed fans and slippers.

Jean Honoré Fragonard (1732–1806), a pupil of Chardin and Boucher, is celebrated for masterfully painted pictures of flirtation and courtship. Fragonard's *The Love*

6.1 *A master of images of love and courtship, Jean-Honoré Fragonard (1732–1806) narrowly escaped death by the guillotine.*

Letter (see fig. 6.1), a charming sketch painted in the 1770s (and now in the Metropolitan Museum in New York), perfectly captures the lighthearted view of love in the Rococo. In the picture, the young girl looks out, drawing the viewer into her confidence, as she tucks a note to her lover into a bouquet.

Fragonard's patrons were all the royal big-shots, like Mademoiselle de Pompadour and Mademoiselle du Barry. But after the French Revolution he was ruined. He was spared the guillotine by David and died penniless.

The Rococo in Italy was in ceilings. One of the most adept draftsmen ever, Giambattista Tiepolo (1696–1770) made grand ceiling frescoes, full of decorative figures swirling up into the distant heavens. One of his favorite subjects was the life of Cleopatra. Tiepolo worked in Venice, in Germany, and ended his life in Madrid.

Francesco Guardi (1712–93) was a one-trick pony: he only painted scenes of Venice. But what a subject! Tourists couldn't get enough of his glorious views of the Venetian canals with their striped poles, elegant palazzos, and gondolas.

NEOCLASSICISM: STAND AT ATTENTION!

The Revolution brought a new civic and puritanical fervor that condemned the light-heartedness of the previous decades on moral as well as artistic grounds. A byproduct of the Enlightenment search for purer ways of thinking, Neoclassicism returned to "antique" conceptual and visual models. This was accompanied by a new moral seriousness that was a reaction to excesses of Baroque and Rococo frivolity. Neoclassicism sought to

cure society's ills through a return to old-fashioned ways, particularly the civic virtues of self-sacrifice, duty and simplicity.

Neoclassical artists echoed these values by reviving the simple designs and restrained ornament of ancient Greek and Roman art. This meant an emphasis on drawing over color. But it also meant a willingness to rip off their ancient predecessors without a guilty conscience. Archeological excavations at Herculaneum and Pompeii (1738–56) popularized antiquity. German art historian and archeologist Johann Joachim Winckelmann (1717–68) was the leading proponent of Neoclassical art, which he said should uphold "noble simplicity and calm grandeur" and copy nature and the ancients. Strange though it may sound, Neoclassical artists proposed to make new art by copying the old. And, by coincidence, the repetitive forms and clear structural relationships of classicism turned out to be perfect for the standardized production techniques of the Industrial Revolution.

Neoclassicism really started with Jacques-Louis David (that's pronounced DA-veed, not Day-vid). His *Oath of the Horatii,* shown at the Salon of 1785, was a big hit and brought back the fashion of people wandering around in togas. Drawn from the Roman and Greek histories of Livy and Plutarch, the painting represents the moment when three brothers swear to defend the city of Rome against barbaric invaders. Its call to patriotic duty came to be seen as prophecy of the French Revolution of 1789.

Another dramatic picture by David, *The Death of Socrates* (1787) (see fig. 6.2), clearly shows the Neoclassical fascination with the civic ideals of ancient Greece and Rome. In David's painting, the great philosopher Socrates is poised to make his heroic self-sacrifice, condemned

6.2 *Severe Neoclassical composition makes everyone in David's* Death of Socrates *(1787) seem especially mournful.*

to death for his refusal to disavow the principles of democracy. Note the dignity of the figures, which are composed as if carved on a classical pediment.

David had a checkered career. He was in sympathy with the Revolution, became a deputy, and voted to behead Louis XIV. Among his revolutionary works was *Death of Marat* (1793), which depicted the dead martyr in his bathtub and raised portraiture to the level of tragedy. After the Reign of Terror ended, David was thrown in jail as a revolutionary. He was let go only after his wife, a royalist who had divorced him for his radical sentiments, interceded on his behalf.

Then David became a brownnose to Napoleon and

served as a kind of minister of culture while painting a series of pictures glorifying the ruler's exploits (*Coronation of Napoleon, Napoleon Crossing the Alps, Napoleon Distributing the Eagles*). After Napoleon's fall, David went into exile in Brussels.

Antonio Canova (1757–1822) was the Neoclassical sculptor par excellance. He carved *Cupid and Psyche, Perseus, Theseus and the Minotaur,* and other antique mythological subjects. His works, though severe, are typified by artificiality and sentimentality. Other Neoclassical sculptors—they all hung out in Rome—were Jean-Antoine Houdon (1741–1828), who complemented his mythological subjects with portraits of contemporary figures like Diderot, Gluck, Rousseau, Voltaire, and Benjamin Franklin; and the Dane Bertel Thorwaldsen (1768–1884), who was so beloved in his home country that he got his own museum in Copenhagen.

David's fame as a painter was supplanted by his young student Jacques Dominique Ingres (1780–1867), who be-

THE INVENTION OF THE MUSEUM

Whose idea was it anyway, to collect all the heritage of civilization in a building designed like a classical temple? One good candidate for the nomination is Napoleon, who more than two hundred years ago opened the first public museum. In 1793, with the help of his buddy David, Napoleon used part of the king's palace, otherwise known as the Louvre, to display the artworks he had gathered from his conquered territories. He called it the Musée Napoléon, and thereby transformed great art from being the privilege of an aristocratic few to a democratic right of all.

came the most celebrated artist of his time. As a young artist, Ingres (pronounced "ang" as in hang) painted portraits and decorative historical paintings. He received commissions to paint Napoleon as first consul (1805) and as emperor (1806). When he went to Rome, Ingres discovered his favorite theme—bathers. Ingres was a confirmed Neoclassicist, and he tried to emulate Raphael, who had copied the classical models. Ingres's work is typified by very sharp outlines, pale colors, and a glassy finish. David said he drew poorly: "The necks have goitre, joints are disconnected and arms and legs a third too long or too short." When he returned to Paris in 1824, Ingres led the academic opposition to Romanticism.

ROMANTICISM: MAKING THE MODELS SWOON

If Neoclassicism sought to discipline the emotions, Romanticism demanded surrender to them. The Romantics celebrated the artist as high priest, and favored irrationality and emotion over logic. See where we get these ideas? Stylistically, Romantic painting was inherently exaggerated and disorderly. Everything about it was antithetical to the order of Neoclassicism. Really a way of life as well as an artistic philosophy, Romanticism was dynamic and complex. It self-consciously emphasized imagination, nature, exoticism (the Orient), the pursuit of excess, and the divided self.

There was a sort of art war between the Neoclassicists and the Romantics. Ingres wouldn't even let his students look at the works of the Romantic painter Delacroix. In earlier times, kings had their court painters and that was that. But now, with the rise of the independent artist,

you had contemporaries vying with one another for power, showing their works at the same shows, competing for prizes. But the two competing schools were really two sides of the same coin.

Eugène Delacroix (1798–1863) was almost the exact opposite of Ingres (so, of course, Ingres considered Delacroix a degenerate). Delacroix was interested in the Orient—its vibrant colors, light, and dynamism. Ingres was interested in the legacy of Roman civilization as exemplified by muted colors and severe linear organization. Delacroix learned how to paint by copying works by Rubens, Veronese, and other old masters at the Louvre. As a result, Delacroix began using divisionist color effects (as Watteau had done) and rugged painterly brushwork; his subjects were derived from romantic poets like Goethe, Dante, and Byron.

Delacroix's painting *The Lion Hunt* (1861) (see fig. 6.3) has everything Romanticism is celebrated for. In this dramatic and violent scene, a Moorish hunting party battles with a ferocious lion and his mate. One man is already down and the lion has another warrior in his claws, while the she-lion pulls a screaming horse and rider to the ground. The scene combines the Romantic love for the exotic with its use of Baroque color and emancipated brushwork.

Delacroix's most famous Orientalist paintings, including *Massacre at Chios* (1823) and the *Death of Sardanapolus* (1827), depict exotic foreign lands as Delacroix imagined them. The only time he actually left France was when he went to Morocco in 1832. He also did portraits and religious paintings and was prolific; he had a retrospective of nearly two hundred paintings in 1862, when he was 64.

6.3 *Romantic painters and their audiences were thrilled by dramatic works like Delacroix's* Lion Hunt *(1861).*

Another major pioneer of Romanticism was Jean Louis André Géricault (1791–1824). A prodigy who loved horses, he won a gold medal from the Academy at age 21 for a painting of a cavalry officer. After studying with Delacroix, Gericault painted *The Raft of Medusa* (1817), based on an incredible political scandal. After the French frigate La Méduse was wrecked off West Africa in 1816, the ship's officers commandeered the lifeboats and one hundred fifty sailors were forced to crowd on a tiny raft—only fifteen survived. Besides its politics, the work is painted with a Baroque exuberance, turning a contemporary event into an epic happening.

The long career of the Spaniard Francisco de Goya (1746–1826) bridged the Rococo and Romantic styles.

His early works are pleasant views of upper-class Spanish frivolity, but after a serious two-year illness in 1792–94—which left him stone deaf—his sensibility took a distinctly darker turn. In the 1790s he executed a series of eighty-two colored etchings called "The Caprices" that are among the most inventive and fantastic social satires ever produced.

The French occupation of Spain (1808–14) had two consequences we take note of today: it spawned the first tactics of guerrilla war and also produced the first expressionist art. Goyàs series of sixty-five etchings produced in 1810–14, "The Disasters of War," are among the most dramatic protests against the insanity of war ever made. Goya's work, according to many art historians, marks the decisive beginning of the modern age.

No discussion of Romanticism would be complete without mentioning the German proto-symbolist Caspar David Friedrich (1774–1840). A quiet guy who lived in Dresden far from the artistic whirl, he hung out with his pal Johann Wolfgang Goethe (you could do worse) and went hiking in the mountains. A dude who got a real spiritual kick out of nature, he painted brooding figures looking out over infinite landscapes lit by sunrise or sunset.

Two of the strangest Romantic artists were two mystics who worked in England: a Swiss artist named Johann Heinrich Fuseli (1741–1825), who settled in England in 1779 and the English poet William Blake (1757–1827). Fuseli started out as a Protestant minister, but his enchantment with Michelangelo led him to become an artist. He introduced new subjects from Shakespeare, Milton, and Dante into the realm of history painting. And he made incredible pictures of erotic fantasies.

Hubba-hubba. Blake was an early British beatnik. A wacky visionary who put out his first book of poems at age 12, Blake wrote the now-famous prophetic poems *Songs of Innocence* (1789) and *Songs of Experience* (1794) to record his rejection of modern society and he designed all of the illustrations, too.

The greatest nineteenth-century landscape painter was the English artist Joseph Mallord William Turner (1775–1851) whose luminous, atmospheric works—he

JOHN RUSKIN—SUPERCRITIC

Father of English-language art criticism, John Ruskin (1819–1900) championed British painters as the best ever at a time when everyone idolized Italian Old Masters such as Raphael. Like critics everywhere, he had a lot to say. An edition of his complete works, compiled after his death, totaled thirty-eight massive volumes, with a 688-page, double-column index. Among his works are the five-volume *Modern Painters* (written over seventeen years, from 1843 to 1860), *Seven Lamps of Architecture* (1849), *Sketches of the History of Christian Art* (1847) and *The Stones of Venice* (1851–53).

The son of a wealthy sherry merchant, Ruskin began his art criticism career as a seventeen-year-old sophomore at Oxford. He could draw himself, and often illustrated his articles with his own copies of the art he was reviewing. He was a big fan of English landscapist J.M.W. Turner and the Pre-Raphaelites. Or he was until 1854, when his wife ran off with the Pre-Raphaelite painter John Everett Millais. Later, after a frustrating love affair with a young woman named Rose La Touche, who was almost thirty years his junior, Ruskin had the first of a series of mental breakdowns in 1871, and his writing trailed off substantially.

THE PRE-RAPHAELITES:
PAINTING THE DRUIDS
. .
Formed in 1848 as a reaction to fake and pompous academic painting, the British Pre-Raphaelite Brotherhood was the art world's first secret society. After daring to criticize Raphael as a poseur, the group was virulently attacked by no less an authority than Charles Dickens, who called one of their pictures "mean, odious, revolting and repulsive." The short-lived group disbanded in 1853. A literary gang, they liked Chaucer, Tennyson, and Keats. Their pictures were known for luminous color, lots of details, and allegorical symbolism. The main guys:

Dante Gabriel Rossetti (1828–82).
A writer who launched the group and then started painting.

William Holman Hunt (1827–1910).
Made detailed religious paintings with lots of symbolism.

John Everett Millais (1829–90).
Also a member.

Edward Coley Burne-Jones (1833–98).
Came after the Pre-Raphaelites, but adopted their love for medieval and mythical subjects.

was especially good at painting bad weather—are precursors to Impressionism as well as all kinds of contemporary painterly abstraction. Turner liked dramatic subject matter like shipwrecks and fires, and his late works (after 1830) became almost wholly abstract. At his death he left about three hundred paintings and more than twenty thousand sketches and watercolors to the nation; they're now at the Tate Gallery in London.

REALISM: SAINTS WITH DIRTY FEET

Lots of painters' work can be called realistic, not least among them Rembrandt, Caravaggio, Vermeer, and Chardin. But the art historical movement known as Realism took place in France between 1848 and 1860, more or less, and was a reaction to the excesses of Romanticism and Neoclassicism.

In part, Realism was about showing life as it was, without any squeamishness or conventionality. Caravaggio's painting of St. Matthew with dirty feet in *St. Matthew and the Angel* (1600) was emblematic of this attitude. Another aspect of Realism was political; the French revolution of 1848 gave Realism a class consciousness that is distinctly modern. One of the first social realist paintings was Gustave Courbet's *Stone Breakers* (1850), now destroyed.

Courbet was leader of the Realist school. He couldn't abide either Neoclassical historical scenes or the poetic literary subjects of the Romantics. He painted things like funerals, with everybody there, looking like they really looked. Critics thought it was ugly and subversive, but Courbet wasn't bothered. "I paint like God himself," he is supposed to have said. "Show me an angel and I will paint one," he said.

Another great Realist was Honoré Daumier (1810–79), a political cartoonist without peer who once did six months in jail for razzing the Emperor Louis-Philippe in the paper *La Caricature* in 1831. His many prints, drawings, and paintings sometimes documented the human condition with straightforward honesty and feeling, but frequently made fun of the bourgeoisie and corrupt political figures. Daumier invented the lawyer joke in an 1836 lithograph.

COMING TO AMERICA

After all this time, the spirit of new art finally crosses the Atlantic and comes to the good old U.S.A., where American painters were busy exploring the rugged terrain of the new land. Part romantic, part realist, these artists were neither. They were different, just as different as their new continent was compared with the old world. These artists considered their landscape panoramas as allegories of their country as a majestic new Eden and also approached their paintings as scientific records of natural scenery. Among the great American landscapists were Thomas Cole (1801–48), Frederic Edwin Church (1826–1900), Albert Bierstadt (1830–1902) and Thomas Moran (1837–1926).

America's two great realists were Thomas Eakins (1844–1916), who lived in Philadelphia and could be called the first photorealist (an artist who paints a picture that looks like it's copied from a photograph), and Winslow Homer (1836–1910), whose naturalistic watercolors of the Maine coast are unmatched for their artistic force and authority. Eakins's masterpiece is *The Gross Clinic* (1875), a painting of a surgeon at work. Even a sincere realist like Eakins had his art scandal. He got tossed off the faculty of the Pennsylvania Academy for unveiling a live female nude in his art class (ordinarily they worked from plaster casts of old statues).

In Homer's *The Gulf Stream,* (1899) (see fig. 6.4), we see the artist at his storytelling best, depicting a black sailor adrift in a dismasted sloop in shark-filled waters. The picture is a masterpiece of Homer's late style, which combines the spontaneity of his watercolors with the strength and power of his oils.

6.4 *Winslow Homer's background as a Civil War sketch artist later allowed him to make realistic paintings like* The Gulf Stream *(1899) even while on vacation in the tropics.*

THE INVENTION OF PHOTOGRAPHY: FROM THE MUG SHOT TO THE SNAP SHOT

The discovery of photography is dated from around 1839 and credited to Louis Daguerre (1787–1851). He perfected the daguerreotype, a way of fixing projected *camera obscura* images on a silvered copper plate. It was the invention of the snapshot—suddenly everybody was getting their picture taken. Criminals too—the mug shot was invented around 1850. Needless to say, artists got worried that the new science, with its detail and accuracy, would put them out of business. Many painters, like Eakins and Degas, used photographs as sources for their own work. And photographers sought

THE INVENTION OF PHOTOGRAPHY:
FROM THE MUG SHOT TO THE SNAP SHOT
(continued)
. .
to make an art form of the new medium itself. Some of
the earliest practitioners:

William Henry Fox Talbot (1800–77).
Invented the negative, published the first photography
book.

Julia Margaret Cameron (1815–79).
Blurry Victorian portraits and tableaux illustrating
Tennyson.

Nadar (1820–1910).
Took pictures of Paris from a balloon. His real name
was Gaspard–Felix Tournachon.

Eadweard Muybridge (1830–1904).
Scientific photo-studies of galloping horses.

Matthew Brady (1823–96).
Photographed Lincoln and the Civil War.

Alfred Stieglitz (1864–1946).
First modernist photographer.

Baron Adolf de Meyer (1868–1946).
Early pictorialist and celebrity photographer.

Edward Curtis (1868–1952).
Noble photos of Indians.

Lewis Hine (1874–1940).
Social reformer who photographed immigrant America.

Jacques Henri Lartigue (1894–1985).
Invented the snapshot as a teen.

SUMMARY

Here's a handy list of marvelous movements of the eighteenth and nineteenth centuries:

🕰 **Rococo** (c. 1730–1800) Sugar-sweet pictures for a frivolous aristocracy.

🕰 **Neoclassicism** (c. 1750–1820). Hard-edged scenes of civic virtue.

🕰 **Romanticism** (c. 1780–1850) Melodramatic illustrations of imaginary subjects.

🕰 **Realism** (c. 1848–75). Bring on the low-lifes and ugly stuff.

IMPRESSIONISM

YOU MUST REMEMBER THIS

Impressionism, which flourished in France from the 1860s to the 1880s, strived for a spontaneity and directness that brought new excitement to the art of painting.

BEST KNOWN FOR

The joy of working vacations—painting at the beach, in the park, in the garden.

IMPRESSIONISM DAWNS ON THE FRENCH ART WORLD

In 1874, a group of young artists whose work had been rejected by the stuffy Salon survey that the Paris art world mounted every year decided to go it on their own. From April 15 to May 15, 1874, they held their own exhibition at the studio of the photographer Nadar, which had become a well-known hangout for bohemian celebrities. The artists in this first official Impressionist exhibition were Paul Cézanne, Edgar Degas, Arman Guillaumin, Claude Monet, Berthe Morisot, Camille Pissaro, Pierre Auguste Renoir, and Alfred Sisley. They named themselves the Société Anonyme, but the satirical journalist Louis Leroy, writing in the April 25 issue of the magazine *Le Charivari*, mockingly called the artists "impressionists," after Monet's painting *Impression, Sunrise* (1872). The name stuck.

When the Impressionists came along, the Paris art scene was dominated on the one hand by pictures of phony Neoclassic nobility and on the other by corny Romantic melodrama. It was all soap opera as subject matter, and the Impressionists were having none of it. They tossed out literary subjects, mythology, and the grand themes of history. They abandoned contour, modeling, and precise detailing. They even gave that celebrated mainstay of art, imagination, the old heave-ho, or so they said, concentrating instead on the close observation of nature. They didn't just look at stuff. They were scientists examining visual phenomena.

And instead of faking it in the studio with models and sketches, the Impressionists took their easels out and painted in the open air (called *plein air* in French). They

WHO'S WHO ☞

Claude Monet (1840–1926).
Lily-pond painter was master of light and color, eventually went blind.

Edgar Degas (1834–1917).
All those ballerinas and he never had sex.

Pierre Auguste Renoir (1841–1919).
Pollyanna with a paintbrush; made dappled pictures of the good life, including copious nudes. Later crippled by rheumatoid arthritis.

Mary Cassatt (1845–1926).
The American Impressionist was a lady from Pittsburgh who lived in Paris. Her specialty: portraits of mother and child.

Auguste Rodin (1840–1917).
An impressionist sculptor, of a sort. Not to be confused with the Japanese monster.

painted in the forests of Fontainebleau, at the Seine, and on the Channel beaches. In this they were following the example of the earlier Barbizon School landscapists, a group of painters who rejected the by-then tired classical stylistic formulas in favor of the direct study of nature. The Barbizon painters were called that because they made their works in the forests around Barbizon, a village about thirty miles southeast of Paris. They were led by Théodore Rousseau (1812–67), but the most famous painter associated with the group was Jean-Baptiste Camille Corot (1796–1875). His serene landscapes, with

their hint of nature's mysteries, were very popular among late-nineteenth-century collectors.

While the Barbizon school landscapes expressed the solitude and quiet of nature in misty shades of gray, green, and earth tones, the Impressionists favored highly colored, light-filled scenes, often populated with picnickers, boaters, and a range of everyday people, frequently seen relaxing on their day off. The painters Renoir and Monet, in their attempt to capture the visual effects of sparkling sunlight in the open air, discovered the technical secret of Impressionism: marks of pure color placed side-by-side to achieve brilliance and luminosity. The Impressionists all but banished brown and gray from their palettes and went so far as to use color to create shadows. What's more, they didn't smooth over the marks of their brushes but emphasized bold and forceful brush-strokes to give their pictures the dynamism of nature.

The Impressionists exhibited together eight times from 1874 to 1886. But long before the group broke up, its individual members had matured and begun to travel their own particular artistic paths.

MONET: RAPHAEL OF THE WATER

Although Impressionism is eternally associated with Paris and French art, London could actually be called the birthplace of the movement. Monet's earliest Impressionist works, including *Impression, Sunrise,* were painted there, and he came back to the city a number of times. In the city's museums are works by Constable and Turner, which provided Monet with inspiration. But arguably more important was the city's atmosphere, its natural haze clouded even further by the smoke of an

ART ACADEMIES, SALONS, AND ECOLES

Although today we think of art-making as the most un-bureaucratic of pursuits, since the Renaissance various official groups have schemed to control the way art was taught and exhibited. The idea of the art academy was originally inspired by Plato's school, called simply the Academy, founded in an olive grove outside Athens by the Greek philosopher, c. 387 B.C.

Art academies supervised the training of apprentice artists, arranged annual exhibitions called salons, and generally labored to uphold standards of artistic correctness. But over the years, most art academies proved hostile to new and creative art. Then the avant-garde artists, whether Courbet or the Impressionists, would make a big fuss. By the end of the nineteenth century, the power of the academies were all but broken. Some of the major ones:

Accademia del Disegno was the first real Renaissance academy. Founded in Florence in 1562 by Giorgio Vasari, it was headed by Michelangelo.

Académie des Beaux-Arts, founded in 1648 by the painter Charles Lebrun (1619–90), was the French national school of fine arts. Its members controlled the only annual public exhibitions in Paris, which were called salons after the gallery in the Louvre where they were held, the Salon d'Appollon. The École des Beaux-Arts was the French academy's official art school.

Salon des Refusés was established in 1863 by Napoleon III after many artists protested that they were being left out of the original Salon.

Royal Academy in London was founded in 1768 and still operates today.

ART ACADEMIES, SALONS, AND ECOLES
(continued)
...

Later on in the twentieth century, whenever somebody like Gertrude Stein (see Chap. 10) would have weekly get-togethers for artists, intellectuals, and other bohemians, they would call it a salon.

increasingly industrial city. "I adore London," he said, "above all what I love is the fog." For Monet, the "mysterious mantle" gave the shapes of the city a special grandness. The hidden inspiration for Impressionism's love of light and air: the dirty dimness of big-city smog!

One painting that exemplifies the Impressionist technique is Claude Monet's *Waterloo Bridge, London, Sunlight Effect* (1903) (see fig. 7.1). This picture shows the famous Thames bridge in afternoon sunlight, seen through a hazy smog that creates a shimmering reflection on the water. The buckskin-colored bridge stands out clearly in the warm sun, while the details of the industrial cityscape that lies beyond are only smudgily indicated in lavender and pearly ultramarine. Monet's color harmony carefully balances warm yellows, oranges, and pinks against the cool blues and grays that mark the shadows and pick out details in the bridge. Little dots of all the colors are repeated throughout the picture to provide a sparkling overall unity. Monet and the other Impressionists perfected this use of the "rainbow palette," called *divisionism*, in which different hues and tones aren't mixed on the palette but achieved by placing pure strokes of color side by side on the canvas and allowing the viewer's eye to blend them optically.

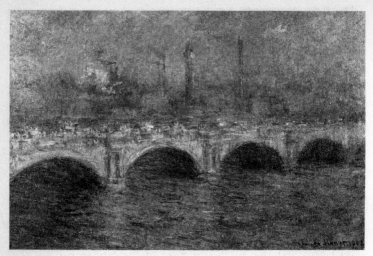

7.1 *Monet's paintings got fuzzier and fuzzier late in life:* Waterloo Bridge, London, Sunlight Effect *was painted in 1903, before he went to the eye doctor*

By the time this picture was painted in 1903, Monet hardly cared at all about the distinctive features of the site that lay before him. Instead he painted the atmosphere, the natural light, the weather. He worked fast, trying to capture the fleeting visual effects, and turning to a new canvas whenever the scene changed. It could be frustrating; at one point Monet had about fifty versions of the Waterloo Bridge scene going at once.

Before all the Impressionist hype exploded and made him famous, Monet had some hard times. After completing his military service in Algeria, the twenty-two-year-old artist hit the slopes around his family home Le Havre in 1862, not skiing but painting landscapes out-of-doors. Five years later, there he is with his mistress Camille giving birth to a son, and him without a sou to his name.

The sheriff seized all his pictures, some two hundred canvases, and sold them for next to nothing. He even tried to commit suicide but his buddy, the painter Frédéric Bazille, helped him out till he got back on his feet.

And what steady feet they were. He painted women in gardens, he painted the Seine at Argenteuil alongside his pals Renoir and Manet, he painted the smoking locomotives at the Gare St. Lazare station, and he painted seascapes and cliffs on the Normandy coast. Perhaps the most dedicated to pure light of all the Impressionists, he began making series of works on the same theme, in which he would paint the same subject—haystacks, poplars, the Rouen Cathedral—over and over under changing light conditions.

In 1883 Monet moved to Giverny, where he bought a house and created the famous gardens that became the inexhaustible inspiration for innumerable paintings of

THE PARIS OF THE IMPRESSIONISTS

The Industrial Revolution of the late nineteenth-century shifted the economic focus of the world to its urban centers. People were attracted to cities because of the availability of work and living space. Artists and intellectuals found the atmosphere appropriate to innovation and experimentation. The new wealth of a rising middle class created a demand for public entertainment of all kinds, from music halls and operas to race courses and public parks. The birth of the urban spectacle was closely attended by artists and writers, who found inspiration in the comings and goings of both rich and poor. Paris stood for what was new—a lifestyle, appearance, political philosophy and public community Europe had never seen before.

water lilies (*nymphéas* in French), first begun in 1899. For the last 30 years of his life, despite increasing problems with his vision, Monet produced these shimmering expanses of intertwined brush strokes of color and light some on a large scale that anticipates the heroic paintings of the Abstract Expressionists. Now on view in Paris's Orangerie des Tuileries, New York's Museum of Modern Art, London's Tate Gallery, and other museums around the world, Monet's water lilies have become a symbol of the cosmic link between man and nature.

DEGAS AND THE CHORUS LINE

A banker's son, Degas was supported by his family in his desire to become an artist. After trying his hand at some atypical history paintings, the young artist discovered the world of the theater, the ballet, and the racecourse. These, together with depictions of the nude, were to become his favorite subjects. An obsessive perfectionist in his art, no one worked harder at chronicling the idle pleasures of the middle class than Degas. One early work, *Cotton Exchange in New Orleans* (1873), a bunch of French-American businessmen sitting around a nineteenth-century office, resulted from a visit to relatives who lived in Louisiana. Perhaps the Big Easy, as New Orleans is often called, can take credit for giving the artist his intense interest in modern life as opposed to historical or mythological subjects.

More than any other Impressionist, Degas was devoted to contemporary society. While Monet was fascinated by the fugitive effects of sunlight and water, Degas was obsessed with casual scenes of everyday life, especially

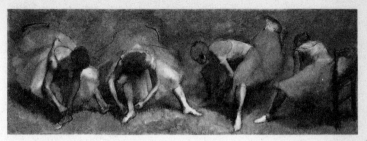

7.2 *Famous for his voyeuristic inclinations, Degas loved to hang around backstage and paint ballerinas.* Frieze of Dancers, *now in the Cleveland Museum, is from 1883.*

scenes of women at work. He painted milliners, dancers, cafe singers, prostitutes, and launderers. Like no artist before him, his compositions are cropped and asymmetrical, with the subjects off to the side of the canvas rather than centered in the middle. By using such odd, almost nonchalant perspectives, Degas's pictures suggest glimpses of the real world. But unlike other Impressionists, Degas scorned the idea of painting in the open air. He constructed his pictures in the studio carefully and obsessively from many preparatory sketches.

A look at the artist's studious method is given by *Frieze of Dancers* (c. 1883) (see fig.7.2), an oil on canvas that shows four sketches of a dancer attending to her slipper from four different angles. She must have had a major knot in her laces! This picture shows the way in which Degas balanced vibrant color and light with careful attention to the building up of form. The awkwardness of this off-stage pose, which gives a behind-the-scenes look at what goes into the glamour of the footlights, is indeed a far cry from the idealized nudes and portraits of the academy.

By 1874 Degas had become a specialist in dance pictures, a principal Parisian entertainment of the time. In those days wealthy male subscribers to the opera would come and hang around during rehearsal, ogling the girls and getting into who knows what kind of trouble. Degas himself was such a privileged onlooker. In his depictions

THE IMPRESSIONIST WOMEN

Not all Impressionist women were naked models posing for the artist. Two, in fact, were accomplished painters themselves. This in a pre-feminist time, mind you, when the lady of the house was supposed to stay at home and rear the kids.

One of the greatest American Impressionists was Mary Cassatt, the Main Line Philadelphia expatriate who lived in Paris starting at age twenty-seven. In *Susan Comforting the Baby* (c. 1881) (see fig. 7.3), you can observe the way in which she uses the free Impressionist brush strokes and unusual compositions found in the work of her friend Degas to focus on the particularly intimate world of mother and child. Done with remarkable technical skill, this picture captures a fleeting moment: Out in her carriage to take the air on a beautiful spring day, the baby has banged her head and her mother hastens to console her before tears break out.

Similarly, the artist Berthe Morisot (1841–95)—Manet's sister-in-law and model (and great-granddaughter of Fragonard)—is also known for her intuitive, vigorous renderings of women in domestic settings. Her paintings of women with children in parks or gardens are particularly notable for their modernity, with the subjects represented as real people, without sentimentality or Madonna-and-Child symbolism.

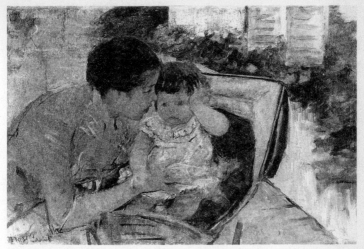

7.3 *Mary Cassatt, one of the few women artists the Impressionists acknowledged, often painted domestic scenes such as* Susan Comforting the Baby, *(c. 1881).*

of dancers one often sees a conflict between the elegant make-believe of the footlights and the more awkward and mundane world that lurks backstage.

He is known as well for penetrating psychological portraits of families and couples, usually so mysteriously suggestive that their details are used for cover illustrations of Realist novels by Zola and Balzac. Degas's studies of male and female relations are still unsurpassed as subtle allegories of the struggle between the sexes. One big mystery about Degas is his own sex life. He never married and as far as scholars can tell, never had any affairs either. He only looked, the eternal voyeur (the guy lived to be 83). Now that's dedication.

From the mid-1880s on, Degas was obsessively preoccupied with pictures of female bathers, usually done in pas-

tel but also rendered with oil on canvas and prints. Degas is also justly famous for sculptures made in wax and bronze and usually depicting dancers, which he would occasionally dress in real outfits as an experiment in heightened realism. He was compensating for his weakening sight with the sense of touch. Curiously, Degas had only one solo exhibition, at Galerie Durand-Ruel in Paris in 1892. Eventually he went almost completely blind, and spent the last twenty years of his life in near solitude.

RENOIR: BIG NUDES

One of five children of a poor tailor, Renoir went to work at age thirteen in Paris as a decorator of commercial porcelains, copying the pictures of the rococo painter Boucher. He scrimped and saved to attend the famous École des Beaux-Arts in Paris in 1862. His early years were marked by poverty, despite occasional successes at getting his paintings into the official Salon. In the 1870s he began to get portrait commissions, which helped him make a living. For the first twenty years of his career, his output consisted of portraits and the occasional big figure painting for the Salon. Meanwhile, he was doing his bit to help invent Impressionism.

Renoir's ability to depict happy times with shimmering color and flickering light is unparalleled. He is famous for his pictures of balls and luncheons and people strolling around Paris. His garden pictures are a lush profusion of flowers and tangled foliage. His landscapes are dazzling displays of the riches of nature. By 1883 or so, his stuff had caught on and he could make a living. So he had a kind of mid-life artistic crisis and decided to

B-LIST IMPRESSIONISTS

Every show has its soloists. But some of the lesser-sung are well worth knowing.

Eugène Boudin (1824–98).
In 1862 he began to paint beach scenes of elegant Parisians dressed to the nines at newly fashionable resorts of Trouville and Deauville on the Normandy coast. Called *"le roi des ciels"* (the king of the skies) by Corot, Boudin shares credit with Jonkind for popularizing on-the-spot landscape painting among the Impressionist group.

Frédéric Bazille (1841–70).
Killed in the Franco-Prussian War at the early age of twenty-nine, Bazille never quite found his Impressionist stride, though his family money enabled him to give financial help to Monet and his other fellow painters.

Gustave Caillebotte (1848–94).
Impressionist painter who was also an important collector of the work of his fellow artists. At his death he willed his collection to the Luxembourg Museum at the Louvre in Paris.

Armand Guillamin (1841–1927).
Celebrated for his lush and colorful landscapes, Guillamin anticipated the Fauvist style (see chap. 9).

Johan Barthold Jonkind (1819–91).
Dutch painter who at age twenty-seven went to Paris and then discovered the beautiful landscape of the Normandy coast, becoming a precursor of Impressionism with his harbor scenes. A big drinker, his career came to a miserable end in a mental hospital.

Camille Pissarro (1830–1903).
A student of Corot, Pissarro was the only artist to participate in all eight Impressionist exhibitions. Working

B-LIST IMPRESSIONISTS (continued)
. .
for a while as a Pointillist (see chap. 8), he was known
for bucolic scenes that stressed pictorial structure over
painterly dash.

Alfred Sisley (1839–99).
Impressionism's most dedicated landscape painter, Sis-
ley ended up the poorest and most modest of the Im-
pressionists even though his artistic career was
originally financed by his wealthy family. He avoided the
crowded pleasure spots his fellow painters made fa-
mous and instead is known for harmonious landscapes
from the countryside around Paris.

change his work all around and start over from
scratch. Typical.

Those voluptuous nudes in opalescent colors, set in
lush summer landscapes, that Renoir is so famous for
represent a new direction in his painting. Renoir de-
cided he wanted to become a classicist, devoted to the
female nude. Renoir strives to replace his free, sketchy
technique with one consisting of distinct contours and
firmness of form. Ingres suddenly becomes his hero.
How un-Impressionist can you get? The imitation of na-
ture was out, classical structure and form was in. His
figures get monumental, even though today they look a
little too much like Boehm porcelain figures.

By the turn of the century, creeping arthritis had re-
duced Renoir to painting with brushes lashed to his
gnarled fingers. In 1913, at age seventy-two and confined
to a wheelchair, he embarked on a career as a sculptor.
The artist undertook his new enterprise not "just to
annoy Michelangelo," he said, but because his dealer

"gently pushed" him into it. Though he was too weak to model anything large by himself, Renoir had two young assistants who shaped the clay under his direction, with the artist guiding their hands with a long pointer. Eventually Renoir made about fifteen three-dimensional works, including the large *Venus Victrix* (1914) and a statue of Madame Renoir suckling their son Jean.

RODIN: SCULPTOR FOR ALL SEASONS

Romantic, Realist, Symbolist, Expressionist—Rodin can't really be included within the confines of any one art movement so we've stuck him here just for fun.

Rodin didn't have much luck starting out. He was rejected three times as a student at the École des Beaux-Arts. His first submission to the Salon, *Man with a Broken Nose* (1864), was sent back. After working in a porcelain factory and decorating monuments by other sculptors, Rodin exhibited a nude male sculpture called *Age of Bronze* (1876) at the Salon of 1877. It was so powerful that he was accused of casting the work from a living model and a committee of enquiry was formed. It was called Rodingate (just kidding).

In 1880, thanks to a pal who was the brother-in-law of a culture ministry bureaucrat, Rodin was given a government studio where he worked for the rest of his life. He launched himself on a monumental work of sculpture, inspired by Dante's *Inferno* and called the *Gates of Hell*. He worked on it until he died—37 years later—and still never finished it. Eventually the *Gates* incorporated a total of 186 figures, including versions of some famous ones like *The Thinker*. He had also put a version of *The Kiss* in the Gates, but later took it out.

Many of Rodin's sculptures caused controversy when they were unveiled, particularly his models of *Victor Hugo* (1893) and *Balzac* (1897). People get picky when it comes to images of their culture heroes. His *Burghers of*

READ ALL ABOUT IT
. .
The great naturalistic novelists of nineteenth-century France were often strong supporters of their fellow artists, the Symbolists, Romantics, Impressionists, and Post-Impressionists. The crusading novelist Emile Zola (1840–1902), for instance, wrote about the artists Manet, Redon, Seurat, Renoir, and Whistler, among others, in the *Revue Indépendent* in the 1880s. Tales of contemporary Paris sprung from the pen of Victor Hugo (1802–85), who wrote *Les Misérables* (1862), and Honoré de Balzac (1799–1850), who called his collection of stories about Parisians "The Human Comedy." These and other writers also made the bohemian life of Paris garrets the subject of their melodramatic pot-boilers, now considered classics. Some examples:

Emile Zola (1840–1902), *L'Oeuvre* (The Work) (1886). A story about an artist, said to be based on Manet.

Honoré Balzac (1799–1850), *Cousin Pons* (1847). A detailed exploration of the psychology of the collector.

Edmond (1822–96) and Jules (1830–70) Goncourt, *Manette Salomon* (1866). A story of a group of artists whose dedication to beauty much inspired Degas.

Marcel Proust (1871–1922), *Within a Budding Grove*, (1919). The adventures of the artist Balbec, a Monet-like figure.

Joris Karl Huysmans (1848–1907), *A Rebours* (Against the Grain), (1884). The story of a decadent aesthete who goes to extremes in the decoration of his house.

Calais (1884–86) was commissioned by the city and finally erected in front of the town hall in 1895. Commissioned to commemorate six heroic citizens who offered themselves up as human sacrifices to spare the city of Calais from destruction by the English in 1347, it demonstrates how Rodin gouged and scraped and polished his work until it expressed the vitality he sought. Rodin wanted the memorial placed at street level, so observers could react to the work as directly as possible. When he died he left his works to the French nation; they can now be seen at the Musée National Rodin in Paris and the Rodin Museum in Meudon.

IMPRESSIONISM AND BOHEMIAN TASTE

Although Americans were still squares as far as vanguard art went—and would remain so for another half century at least—one native of Lowell, Mass., did go abroad in search of bohemia. After flunking out of West Point and following employment as a clerk in that burgeoning home of bureaucracy, Washington, D.C., James Abbott McNeill Whistler (1834–1903) decided to go to Paris and become an artist in 1855 (he settled in London five years later). His interest in simplified and asymmetrical compositions was further influenced by the fad for all things Japanese—called *Japonisme*—that swept Europe in the 1860s.

Whistler's *Nocturne in Black and Gold: Falling Rocket* (c. 1874) shows the kind of simplified composition that the artist was after. It substitutes washy gradations of muted color for Impressionism's vigorous brushwork, and though the painting looks abstract it is in fact a careful

WHISTLER'S (COMPLAINING) MOTHER

portrayal of a fireworks display. He named his pictures "nocturnes," "harmonies," and "arrangements" to emphasize their importance as evocative compositions of abstract elements. For example, the famous portrait of Whistler's mother is actually titled *Arrangement in Black and Gray No. 1: The Artist's Mother* (1871–72).

Whistler's compositions may have been simple, but his lifestyle was ornate. Like Oscar Wilde, Whistler was an early proponent of art for art's sake, and became a high-profile figure on the streets of London, carrying a long cane and wearing white trousers and shoes with pink bows. In 1877, the *Nocturne in Black and Gold* became the focus of a notorious lawsuit after critic John Ruskin called Whistler a "coxcomb" for "flinging a pot of paint in the public's face." Whistler sued for libel but won a moral victory only, receiving an award for damages of one farthing.

MANET: MODERNISM'S MAIN MAN

Though Manet didn't paint like the Impressionists, and never exhibited at any of the Impressionist shows, he hung out with them. He was a real scandal-monger, who could take conventions of proper behavior and turn them on their head in the most provocative way. His famous picture, *Le Déjeuner sur l'Herbe* (*Luncheon on the Grass*), caused a scandal when it was exhibited in 1863 at the Salon des Refusés, a kind of outsider show organized to compete with the official salons. It looked like two fully clothed men picnicking with two naked women in a public park—a scene of flagrant immorality! In fact, Manet had adapted similar pictures of the same theme painted by Raphael and Giorgione, and just modernized the scene and put everyone in contemporary garb (or out of it, as the case may be). One nude woman in the scene looks right out of the picture at the spectator, an effect the Parisian art audience found particularly scandalous.

With this astonishing mix of the classic and the modern, Manet became the hero of the Impressionist generation. He recorded a series of scenes from beer halls and cafés, in which his mastery of the brush is matched by his skill as a recorder of contemporary life. In Manet's *A Bar at the Folies-Bergère* (1881–82) (see fig. 7.4), which was in fact painted from a model posing in his studio, he straightforwardly depicts an everyday urban scene without traditional literary excuses or traditional painterly devices. The barmaid looks bored as she waits for your order; you can practically hear the hubbub of the crowd at the tables seen in the mirror behind her. The legs of a trapeze artist dangle down in the top left of the

7.4 *By organizing a complex image of real and reflected space, Manet zeroes in on the psychological distance between characters in his* Bar at the Folies-Bergère *(1881–82).*

picture. This painting shows the clean lines and flattened volumes of Manet's painting, which used black with unprecedented graphic effect.

Manet died in 1883, after suffering for years from a debilitating illness—perhaps syphilis—that affected his legs. Bedridden in the last months of his life, he completed a series of simple still lifes of flowers that are praised for their spontaneous mastery.

SUMMARY

- The Impressionists exhibited together but painted in varying styles.

- Impressionist painters were interested in the effects of light and atmosphere.

- Impressionism is known for perfecting the technique of divisionism, in which dashes of complementary color were placed side by side on the canvas to create shadows.

- Impressionists planned their pictures very carefully in order to reproduce the spontaneous experience of daily life.

POST-IMPRESSIONISM

YOU MUST REMEMBER THIS

The Postimpressionists did not seek to imitate the real world as much as create their own world of feeling, form, and spirit.

BEST KNOWN FOR

A grab bag of styles, all using bright colors, splashy brushwork, and raw subjects.

COLOR, FORM, AND LINE
TAKE COMMAND

Postimpressionism is a great name for an art movement—even if none of the artists involved had ever heard of it! The term was actually invented years later by a pair of British critics.

The writer, editor, and museum director Roger Fry (1866–1934) used the term in 1910 and 1912 for two shows at London's Grafton Galleries of works by the modern French masters, notably Cézanne, Gauguin, and Matisse, with a few Cubists thrown in for good measure. The English aesthetician and critic Clive Bell (1881–1964) also used the name in his book of essays, *Art* (1914).

Thus history was made, a couple decades late.

So Postimpressionism, not to put too fine a point on it, is a catch-all term that describes art that came after Impressionism. From the 1880s to the end of the century, Postimpressionist artists kept Impressionism's bright colors but added a whole new focus on meaning, whether primitive, mystical, or scientific.

SEURAT: DOT-MEISTER SUPREME

Methodical and hard-working, Georges Seurat was an egghead who approached his art like a scientist doing experiments. In his day, the modern study of optics and perception was really beginning to take off. Seurat immersed himself in theories of the psychology and physiology of vision, like the treatise on color contrasts of chemist Michel Chevreul (1786–1889). He was also inspired by the divisionism of Romantic painter Eugène

WHO'S
H
O
☞

Paul Cézanne (1839–1906).
The father of modern art painted a mountain over and over and over again.

Paul Gauguin (1848–1903).
Wild man and artist of bright colors and primitive mysteries, went to Tahiti, died of syphilis.

Vincent van Gogh (1853–90).
Every brushstroke is alive in his intense expressionistic scenes. And yes, he did cut off his ear.

Georges Seurat (1859–1891).
Such a careful artist, he painted one dot at a time.

Henri de Toulouse-Lautrec (1864–1901).
Colorful scenes of Paris cabaret life from the short guy played in the movies by José Ferrer.

Delacroix. Artists like Seurat hoped that modern science would help modernize art.

So Seurat came up with a customized version of Impressionism that reduced its intuitive brushstroke to a carefully applied dot of pure color. According to Seurat's theory, this swarm of dotted strokes would be blended by the eye to make the painting more luminous and naturalistic than ever before.

The style had a confusing swarm of names. Seurat called it "chromo-luminarism," but he was the only one. The French art critic Félix Fénéon, who championed the short-lived movement, dubbed it Neoimpressionism in

1886 in a review in the Brussels periodical *L'Art Moderne*. The painting method was also called divisionism and eventually was renamed pointillism, now the most widely accepted general term for the technique.

In 1884, after being rejected by the official Salon, Seurat cofounded the Salon des Indépendants and exhibited the first major pointillist painting, *Bathing at Asnières* (1883–84). But he perfected the technique in his major work, *A Sunday Afternoon on the Island of La Grande Jatte*, 1884–86 (see fig. 8.1). This huge painting, which took two years to complete, became notorious—now at the Art Institute of Chicago, it has even been called the most famous painting of the decade.

What was the big deal? Well, besides its huge size,

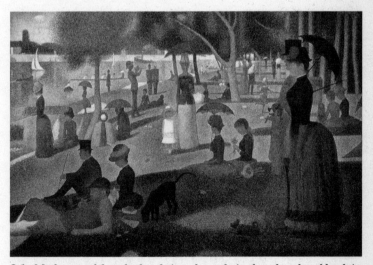

8.1 *Made up of hundreds of tiny dots of single color that blend in the viewer's eye, Seurat's huge* Sunday Afternoon on the Island of La Grande Jatte *(1884–86) is a key Postimpressionist work.*

there's the long-tailed monkey on a leash held by the woman at the right. Actually, Seurat's masterpiece depicts ordinary Parisians enjoying an outing in a park on an island in the Seine. The culmination of his attempt to create a monumental style, Seurat's work is an interplay of geometrical harmonies, lightened with grace notes such as butterflies, bows, bouquets, and puffs of smoke. To create the giant canvas, the artist compiled more than fifty drawings and studies. Seurat liked it so much he showed it at the final Impressionist exhibition in 1886, the Salon des Indépendants show in 1886 and a Neoimpressionist exhibition in Brussels in 1887. Seurat had started with the dots at age twenty-three in 1882, but his career was cut short when he died of a severe infection at thirty-two.

The Neoimpressionists included Paul Signac (1863–1935), the theoretician of the group who became its leader after Seurat's death in 1891. Other Seurat disciples included the now all-but-forgotten artists Charles Angrand, Henri-Edmond Cross, Albert Dubois-Pillet, and Maximilien Luce. More importantly, the Neoimpressionist mix of art and science, although it now seems rather formulaic, proved to be historically influential. It spread to Belgium and Italy; a number of important artists went through Neoimpressionist phases, including Pissarro (1885–90), Gauguin (1886), Toulouse-Lautrec (1887), and van Gogh (1886–88). Matisse's 1899 pointillist phase, with its emphasis on pure colors, led to the discovery of Fauvism (see chap. 9).

CÉZANNE: LONELY GUY

Originally a minor Impressionist who took more than his share of flack from the critics, Paul Cézanne had

*Paul Cézanne
(1839–1906)*

trouble being a bohemian. He didn't like Paris and never stayed there long. By the 1870s he had dropped out and moved to the south of France, living first near Pontoise where he painted with his buddy Pissarro, an important influence, and then at his family home, Aix-in-Provence. For years Cézanne painted all alone in the countryside, really slowly and with great care, laying down a brushstroke at a time. This was his great discovery—putting together a picture piece by piece, like a jigsaw puzzle of solidly constructed color, form, and mass.

Using only a few hues like yellow ocher, grass green, and sky blue, Cézanne built up pictures of zenlike serenity—landscapes you can't take a walk in and still lifes that don't suggest mealtime. A hypochondriac (he had diabetes) who argued with his friends (who included the French writer Emile Zola and the Impressionist Claude Monet), Cézanne rarely explained the point of his pictures. Art historians have been having a field day ever since trying to figure them out. One highbrow opinion: his paintings aren't so much pictures of things as they are philosophical meditations on the nature of reality itself.

The son of a prosperous banker, Cézanne hid his girlfriend, Hortense Fiquet, from his father for some seventeen years, even after they had a son Paul in 1872 (why would anyone do such a thing?). He finally asked his dad to okay their marriage in 1886, which the old man did. Cézanne's father died later that year, leaving him a

large inheritance. The money seems to have allowed him to come into his own as an artist.

In the last twenty years of his life, he produced a series of portraits of his wife, Madame Cézanne, many landscapes inspired by the Mont Sainte-Victoire and other scenes, the famous still lifes of apples and oranges, and the innumerable *Baigneurs* and *Baigneuses* (that's French for male and female bathers). Although he was not given his first one-man show until 1895 by the Parisian dealer Vollard, by the end of the century Cézanne was revered as a sage by many of the younger avant-garde.

Cézanne's final masterpiece, *The Large Bathers* (see fig.

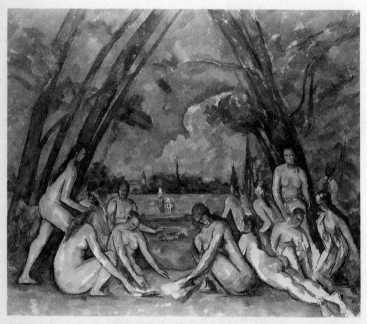

8.2 *In* The Large Bathers *(1898–1905), you can see how Cézanne built up his images from cones, cylinders, and pyramidal shapes.*

8.2), which he worked on from 1898 to 1905, is an almost abstract version of a classical motif, an arrangement of planes and colors that is at the same time a mythological scene of nudes in the landscape. In his arcadian vision, Cézanne groups his figures in a shallow frieze spanned by a broad arc and framed at both sides by trees. Women at the turn of the century did not bathe naked in streams and sun themselves on the banks. But Cézanne has used this classical motif of the nude in the landscape as a pretense to build a totally modern art combining French classicism with contemporary Realism.

In 1904, Cézanne wrote a letter to the painter Emile Bernard, saying, "Interpret nature in terms of the cylinder, the sphere, the cone; put everything in perspective, so that each side of an object, of a plane, recedes toward a central point." This remark became the intellectual springboard for Cubism and the abstract art that followed.

Cézanne takes a break

TOULOUSE-LAUTREC:
LE DEMI-MONDE, C'EST MOI

The son of a French nobleman, Henri de Toulouse-Lautrec broke both his thighbones in two consecutive falls as a teen. His legs did not heal well and consequently he remained a cripple. But the guy was brave, and boy could he draw. Denied a normal life by this misfortune, Toulouse-Lautrec found acceptance in the cafés and dance halls of Montmartre in Paris. By the time he was twenty-five he had mastered a poster style inspired by Art Nouveau, Gauguin, and Japanese art that combined bold flat colors and imaginative layouts to create lively scenes of contemporary French amusements.

Art talk was anathema to Toulouse-Lautrec. "Forget it!" was what he told anybody who wanted to discuss his work. He saved his unusually generous wit and sympathy for his subjects—actresses, clowns, singers, circus performers, courtesans, drinkers, and their bourgeois audience. In 1890 he began his famous illustration of the scenes at the Moulin Rouge cabaret and also produced pictures of life at Paris's *maisons closes* (that's French for whorehouses).

During his career Toulouse-Lautrec produced lithographs and posters, illustrated books, drew for magazines and newspapers, and made decorative artwork for theater programs and menus. He had two solo shows, at the Goupil Gallery in Paris in 1893 and at Goupil's London branch in 1898. But staying up all night drinking has its downside, needless to say. In 1899 he entered a detox clinic, but continued to drink and died in 1901 at age thirty-seven. In 1922 his mother gave some six hundred

Henri-Marie-Raymond Toulouse-Lautrec (1864–1901)

of his works to the town of Albi, where today they are exhibited in the Musée Toulouse-Lautrec.

GAUGUIN: CIVILIZATION IS A DISEASE

The son of a French journalist and a Peruvian Creole mother, Gauguin was not your average guy. He lived in Peru as a boy, spent six years as a sailor, and ended up in Paris at age twenty-four, a hard-working stockbroker with a wife and (eventually) five kids. But by the early 1880s he had fallen in with Pissarro and the other Impressionists and was inspired to become a painter. Uh-oh.

Before you know it, Gauguin quit his job, sent his fam-

ily back to his wife's home in Copenhagen, and set off in search of a truer life, free of the phony inhibitions of French civilization. In 1886 he went to Brittany, the most primitive part of France, to live and work with the superstitious French peasants. There he hung out with van Gogh and worked with the painter Émile Bernard, who advocated a style called Cloisonnism, after cloisonné enamels, which uses simple, flat forms in vigorous colors outlined by strongly marked arabesques. In 1887, during a brief trip to the Caribbean, he worked as a laborer on the Panama Canal.

Before long, Gauguin launched his own style, which he called Synthetist-Symbolic—synthetist because it's built up from symbols and symbolic because it's not a copy of the real world but symbols of images and ideas. It's a name that didn't stick, thank goodness. A combination of influences from Cloisonnism, Japanese art, medieval stained glass, folk art, and primitive sculpture, Gauguin's style used a fluid line and strong colors to depict scenes that he hoped had a primitive mystery and power.

In 1889 he showed the stuff in a café and immediately gained a crew of disciples (a magnetic guy, that Gauguin), which became known as the school of Pont-Aven. The next year, back in Paris, Gauguin was heralded as a Symbolist and began hanging out at the Café Voltaire with the poets and artists of that movement. But he couldn't stand all the high-falutin' talk, and besides, he was bankrupt, so he split for Tahiti in 1891, the first of three trips he made to the South Seas.

He lived a primitive life in a jungle hut for a couple of years, making these great spooky paintings of Polynesian mysticism with titles like *Manao Tupapau,* or *The Spirit of*

the Dead is Watching (1892) (see fig. 8.3). This picture shows Gauguin's young *vahiné*, or native girlfriend, lying on a bed covered with a yellow native cloth made from bark. Behind her on the wall, painted purple to suggest terror, are the white *hotu* blossoms, the phosphorescent "flowers of the tupapaus," or ancestral spirits. There's one, hooded, watching at the foot of the bed. Notice also the arabesques of wavy contours that snake through the picture.

Back in Paris, broke again, Gauguin inherited thirteen thousand francs from his uncle and lived a riotous life with an exotic character called Annah the Javanese, who

8.3 *Everyone knows that Gauguin went to Tahiti, but his painting* Manao Tupapao (The Spirit of the Dead is Watching) *(1892) actually shows what he did there: terrorize underage girls.*

he painted in a famous 1893 nude portrait. Annah absconded with his studio contents and Gauguin left France for the tropics—1895—where he lived on Tahiti among the natives. As before, he sunk into illness and poverty, without money even to buy bread. He lived off the fruits of the island: mangos, guavas, and shrimp.

And he worked like a maniac, painting bold and brilliant scenes of Tahitian life. He made woodcuts, carved sculpture, painted, and wrote *Noa-Noa*, a manuscript

SYMBOLIST ART

Sick of three decades of concrete reality? The obsession of both Realism and Impressionism with the perceived world soon gave rise to a contrary movement, Symbolism, which sprang up around 1885 in conjunction with French Symbolist poetry. Old-fashioned in painting style, the gang had a millennarian taste for kinky psychology and mystical subjects. It was the beginning of the modern cult of decadence, a fascination with evil and death. Besides Gauguin, who dabbled with the group, the main men were:

Pierre Puvis de Chavannes (1824–98).
Universally liked muralist with a taste for arcadian scenes in pale colors.

Odilon Redon (1840–1916).
Lithographer whose dreamy scenes are populated by eyeballs, flowers with faces, and other weird creatures.

Gustave Moreau (1826–98).
Matisse's teacher, he painted bejewelled scenes of myth and imaginary civilizations.

Eugène Carrière (1849–1906).
Friend of Mallarmé and Verlaine, he painted blurry mystical scenes of motherhood.

about being an artist in Polynesia. He died exhausted and broke in 1903. If you want a fictionalized biography of his romantic artist's life, read Somerset Maugham's *The Moon and Sixpence.*

VAN GOGH: THE MAD MONK OF POSTIMPRESSIONISM

The very model of the tormented genius, Vincent van Gogh loved humanity but couldn't get along with people. The son of a Calvinist minister, he got hung up on what we call today "inappropriate love-objects," namely, his cousin and assorted prostitutes and unwed mothers.

And he couldn't keep a job. Part of a family of Dutch art dealers, van Gogh was fired from the family art gallery in 1875. Inspired by religion, he worked as a missionary to coal miners before his overzealous behavior got him dismissed in 1879. A real basket case, he lived like a tramp for months before taking up art, creating pictures of peasants and fisherman in a dark sad style.

In 1886 he went to Paris to visit his younger brother Theo, an art dealer who would be his confidant and supporter all his life. (Even with an art dealer for a brother, van Gogh only sold one painting while he was alive.) He met all the other Postimpressionists. He lightened his palette and developed his own version of Impressionism stressing thick pigment, bright color, and long straight strokes that create patterns of contours across the picture surface. His intense personality finally found an good outlet: van Gogh's pictures are among the most psychologically powerful ever made.

In search of clearer skies (and peace of mind), van Gogh moved to Arles and struck up his famously tempes-

tuous friendship with Gauguin. From 1888 until his death in 1890 he painted like a maniac (it was also during this period that he cut off his ear to present to a prostitute). In *Starry Night* (1889) (see fig. 8.4), one of the artist's most famous images, you see a scene that seems to throb with a dark, almost religious ecstasy. Gold stars swirl in a cosmic blue sky above town that seems bewitched. Swirling cypresses reach verdant fingers from the frozen earthly realm to touch mad heavens.

With a vision like this, it's no surprise that van Gogh sought help. In May he went to Auvers and placed himself under the care of Dr. Paul Gachet. He kept working:

8.4 *No hallucinogens back then. Vincent van Gogh's* Starry Night *(1889) was pure inspiration—as seen from his room in the insane asylum.*

in the last seventy days of his life he painted seventy canvases. Finally, suffering from hallucinations (he's now thought to have been an epileptic), the artist shot himself in the chest with a pistol on July 27 and died two days later. He left behind a voluminous correspondence with his brother Theo, some seven hundred fifty letters, that explain what he was after, in art and life, with lucidity and conviction.

THE NABIS

Gauguin's Tahitian pictures, shown in 1893 at Galerie Durand-Ruel, inspired yet another circle of artists, mostly students at the Académie Julian in Paris, to launch yet another short-lived art movement. Named after the Hebrew word for prophet, the Nabis advocated a philosophy of art that stressed line and pattern, often applied to intimate interior scenes.

The Nabis hung out at the editorial offices of the *Revue Blanche*, which published many of their works. They designed costumes and stage sets, illustrated books, and created posters and stained glass, spreading their influence throughout the *fin de siècle* (French for "turn-of-the-century") art world.

Among the important practitioners were Maurice Denis (1870–1943), theorist of the movement, who is remembered for a very quotable definition of art: "Remember that a picture—before being a horse, a nude, or some sort of anecdote—is essentially a flat surface covered with colors assembled in a certain order."

Other talented Nabis painters were Pierre Bonnard (1867–1947), Édouard Vuillard (1868–1940) and the Swiss-born Félix Vallotton (1865–1925). Toulouse-Lautrec was associated with the group, and Aristide Maillol (1861–1944) was a member before he took up sculpture.

ART NOUVEAU: DIG THOSE CURVES

A decorative style that emphasized arabesques and ornamentation, often using floral and other plant forms, Art Nouveau was originally named after a shop that opened in Paris in 1895. In German-speaking countries, it was called *Jugendstil*, after the journal *Jungend* (youth), founded in Munich in 1896. The sinuous line of Art Nouveau influenced the work of painters like Toulouse-Lautrec and Gauguin, and affected the applied arts generally throughout Europe. Its effect can be seen in the architecture of the Spaniard Antoni Gaudí (1852–1926), the ornamental ironwork of the Paris Metro entrances by Frenchman Hector Guimard (1867–1942), the illustrations of the English aesthete Aubrey Beardsley (1872–98), the glassware of Émile Gallé and the stained-glass and architectural ornament of the Belgian architect Victor Horta (1861–1947).

In Vienna the word was spread by the Vienna Sezession, founded by Gustav Klimt in 1897 (see chap. 9).

Exhibitions of this group and its periodical, *Ver Sacrum*, helped publicize Jugendstil.

SUMMARY

⏱ Postimpressionism is particularly good on posters, mostly by Cézanne, Gauguin, van Gogh, Toulouse-Lautrec, and Seurat.

⏱ Postimpressionism is a hybrid term used by common agreement to describe French painting in the last fifteen years of the nineteenth century.

⏱ Postimpressionism replaced by Impressionism's blurred haze of brush strokes with sinuous lines and solid colors.

⏱ Postimpressionism discarded the Impressionist emphasis on how the eye sees the world with its own search for how the tormented human mind understands it.

EXPRESSIONISM

YOU MUST REMEMBER THIS

After Gauguin and van Gogh showed the way, art abandoned its traditional goal of depicting nature and exploded into the twentieth century with violent colors, abstract forms, and emotional subjects in an attempt to express the contemporary mind.

BEST KNOWN FOR

Communicate your inner vision, and boy is it distorted!

FEELINGS, WHOA-WHOA-WHOA, FEELINGS

Just what is Expressionism, anyway? That is, besides Joe Cocker and Axl Rose jerking around on stage? In art, Expressionism is sometimes used very broadly to define any art that is intense and emotional, like works by the great Renaissance painter Grünewald or the early nineteenth-century Spanish genius El Greco. But more specifically Expressionism can be traced to the 1880s—van Gogh and Gauguin were forerunners—when vanguard artists stopped trying to depict the real world so much as their subjective response to things.

Expressionism was the first big movement of the twentieth century. It began in Paris with Fauvism, a distinct aesthetic program whose tenets were almost immediately picked up by a group of German artists who called themselves *Die Brücke* (The Bridge) and not long after by another group called *Der Blaue Reiter* (The Blue Rider). The term *Expressionism* was actually coined in 1911 by a German critic to describe an exhibition of Fauves, early Cubists, and other modernists. But it spread far and wide, defining the cult of the individual that is still with us today.

MUNCH, ENSOR, AND ROUSSEAU: WEIRD AND WACKY

First and foremost among the early Expressionists was Edvard Munch, the Norwegian painter and printmaker whose 1893 work *The Scream* is now popularly available in an inflatable plastic three-dimensional form at Toys R

Us. A sad fate for an artist whose themes were pain, death, and perverse love! Just listen to the titles of some of his paintings: *Anxiety*, *Melancholy*, *Despair*, *Ashes*, *Jealousy*, *The Death Chamber*. Get out the Prozac! As an artist he relied on brazen color and linear distortions to express elemental emotions.

Perhaps it is no surprise, but Munch had a tough childhood. Besides being sickly himself, his mother died when he was five, his sister Sophie died of tuberculosis, and his father, being a doctor, was surrounded by sick people. Munch's youthful career stretched from his first visit to Paris in 1885 at age twenty-two to the time he checked into a Copenhagen clinic after a four-day drinking binge in 1908. He stayed for eleven months, and never went back to Paris. He calmed down some after

WHO'S
H
O
☛

Expressionism began in France, prospered in Germany, and developed all over Europe.

Edvard Munch (1863–1944).
The original *Scream* guy.

Henri Matisse (1869–1954).
Fauve who became king of color.

Wassily Kandinsky (1866–1944).
A smudge here, a slash there, and you've invented abstraction.

Amedeo Modigliani (1884–1920).
The original bohemian; lived in a garret and died of tuberculosis.

that. Today, the best collection of his work is at the Munch Museum in Oslo.

As you might expect, the poor guy had his share of problems with women. Munch's lithograph *The Sin* (1901) (see fig. 9.1) shows a long-haired, bare-breasted, starry-eyed, woman confronting the viewer. A person would have to be nuts not to note the suggestiveness of the young woman's loosely worn hair and the languorous line that traces her form. But these details only demonstrate the artist's obsession with what he called the "horrible cosmic-power" of sex. Supposedly the model was Munch's one-time lover Trudy, who had a little trouble breaking up with the artist. First she said she was dying, then when he wouldn't stop bugging her, she threatened to shoot herself. He tried to wrestle the gun away and she accidentally wounded him in the hand. Ouch.

Another precursor of Expressionism was the Belgian painter James Ensor (1860–1949). Ensor saw humanity as one big freak show. He loved to paint really garish pictures of creepy-looking people wearing ugly carnival masks. He also made still lifes of shells that seem about to crawl off the canvas. Though he was doing his best work in the mid-1880s after seeing the Impressionists, he was stuck in Ostend and his work was never seen outside Belgium before 1900.

At the other end of the scale from Ensor was the French eccentric Henri Rousseau (1844–1910), whose totally charming pictures have some of the naiveté of folk art. A self-taught painter, Rousseau first earned his living as a toll collector (thus his sometime appellation, *Douanier*, meaning "customs agent" in French) and took up art only during his retirement, exhibiting for the first

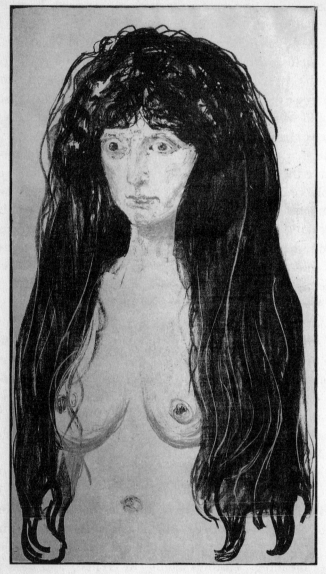

9.1 *Edvard Munch's obsession with what he called "the cosmic power of sex" is evident in his haunting lithograph* The Sin *(1901).*

time in the 1886 Independent Salon. The general public thought he was a big joke but the avant-gardists dug him. Rousseau was the first "outsider" artist, but now you can find his works in the greatest museums around the world.

One of his major pictures, now at the Museum of Modern Art in New York, is *The Dream* (1910) (see fig. 9.2). It has an air of sweet and unaffected mystery. Rousseau's marvelous imagination creates a peaceable kingdom, meticulously composed in a rhythm of branches, leaves, and figures assiduously painted so that the brush strokes are hidden. His vision is all the more utopian if you know that his sources for his fantastic tropical jungle were actually postcards and illustrated magazines and that the exotic animals were copied from toys bought in Paris shops.

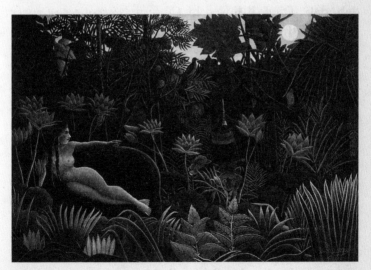

9.2 *Henri Rousseau actually used a stuffed toy as a model for the lion in his childlike painting* The Dream *from 1910.*

FAUVISM: FLAME ON!

Fauvism was a short-lived association of artists who painted your unremarkable everyday art subjects—portraits, still lifes, landscapes and river scenes—in flame-brilliant hues. The group first stunned the art-loving public in 1905, when the large central gallery of the vanguard-artist-selected Salon d'Automne was given over to its works. Legend has it that the critic Louis Vauxcelles, noticing a Renaissance bronze in the center of the room, exclaimed, "Donatello among the Wild Beasts! (*Les Fauves*)." (Vauxcelles would later name the Cubists, too.)

Matisse, who was older than the rest (in 1900 he was married with three kids), had a leading role in the new movement. He had been experimenting with pointillism and was frankly finding it rather tiresome. Dab, dab, dab, dab, dab. Then, inspired by Cézanne's creation of space through his use of color and influenced by the large van Gogh retrospective in 1901 at the Galerie Berheim-Jeune in Paris, Matisse hit his stride. He began spreading broad masses of intense color across the canvas. For him it was the road to the emotional and symbolic use of color. "The chief aim of color," Matisse said in 1908, "should be to serve expression."

One of the great bohemians of the early Paris art scene was the Fauve Maurice Vlaminck, a bear of a man who had been a bicycle racer and a fiddler. An anarchist who was as spontaneous as he was unconventional, Vlaminck refused to go to museums because "visiting the Louvre saps your strength." For him, art was a hobby; after painting in the fields all day, he would scrub his canvases clean of paint before carrying them home, until

his buddy Derain talked him into saving them. Then, he began painting with great vigor and in the end was transformed by it. "I transposed into an orchestration of

WHO'S
H
O
☞

The Fauves

Who were these guys that gloried in pure color? Besides Matisse, you had:

Maurice Vlaminck (1876–1958).
The wildest of the Fauves, he used thick, emphatic brush strokes.

André Derain (1880–1954).
Known for Orientalist-influenced landscapes in bright colors.

Kees van Dongen (1877–1968).
Dutch-born bohemian who painted big-eyed vamps overflowing with sensuality.

Georges Rouault (1871–1958).
Fervently religious, he painted pictures that looked like stained-glass windows.

Georges Braque (1882–1963).
That's right, the cofounder of Cubism actually got his start as a Fauve.

Albert Marquet (1875–1947).
Matisse's pal, he specialized in harmonious landscapes.

Raoul Dufy (1877–1953).
His airy drawing and sparkling colors were also good for textiles, ceramics, and book illustrations.

pure colors all the feelings of which I was conscious," he wrote later. "I was a barbarian, tender and full of violence."

The Fauvist flame burned out after 1908. In France it was overshadowed by a new artistic revolution, one called Cubism (see chap. 10). The original Fauves scattered. Braque became a Cubist, Van Dongen settled in Monaco and became a society portraitist and Vlaminck eventually retired to a farm in the country and painted landscapes in a more traditional mode. Though short-lived, Fauvism proved to be influential, inspiring German Expressionism as well as the invention of an abstract art of pure color.

MATISSE: MAESTRO
OF THE SPECTRUM

So Fauvism was finished. But Matisse's career was just beginning. Over the next four decades he would be heralded as the greatest colorist of the twentieth century—and as Picasso's main rival. For Matisse, art became an expression of lyrical harmony and bliss, an expression of what could be called an emotional utopia. "What I dream of," he wrote in 1908, "is an art of balance, of purity and serenity devoid of troubling or disturbing subject matter . . . like a comforting influence, a mental balm—something like a good armchair in which one rests from physical fatigue." Besides creating easel paintings and murals, Matisse also made bronze sculpture, was a master of etching, lithography, woodcuts, and illustrated books by Baudelaire and Mallarmé (among others) and designed stained glass, tile murals, and other decorations for the Chapel of the Rosary in Vence in the south of France in 1951.

As the story goes, Matisse was working as a clerk when he read a how-to book on painting at age twenty-one and chose an art career, making his first painting, *Still Life with Books*, in 1890. His career is usually broken down into three parts. The early years include Fauvism and various pictorial experiments with Cubism and exotic oriental patterning (he first visited Morocco in 1911). After World War I he settled in Nice, where he lived for the rest of his life, painting deliciously colorful pictures of interiors and odalisques. Matisse kept a bazaar's worth of fabrics, hangings, and exotic props so he could transform his ordinary French apartment into some kind of sultan's vision. Finally, in his last years, in failing health, he perfected the *papiers découpés* (French for "paper cutouts"), large decorative works in which scissors substituted for the brush and sheets of brightly colored paper replaced palette and paint.

One of Matisse's early masterpieces, *Dance I* (1909) (see fig. 9.3), demonstrates the artist's passage from the violent hues of Fauvism to the use of color as the vehicle for a serene and decorative harmony. The painting is reduced to its simplest form. Colors are applied in continuous planes of pure green, blue, and pink, while the figures inscribe an arabesque across the field. According to the artist, the painting was inspired by the sight of some Catalan fishermen doing the sardana, a folk dance, at the beach at Collioure in 1905. And while working on the painting, Matisse hummed the tune of a Provençal farandole he had heard at the Moulin de la Galette. In any case, Matisse associated the dance with life and rebirth, as well as with a kind of Dionysian potency.

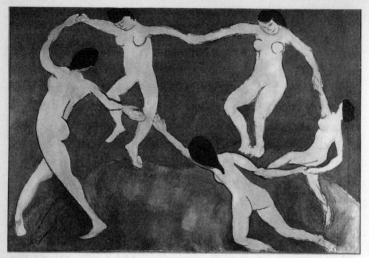

9.3 *Art is a good armchair: Matisse's sublimely restful* Dance I
(1909) uses a minumum of line and color.

GERMAN EXPRESSIONISM:
GRIMACES AND GROANS

The long and fertile tradition of twentieth-century
German Expressionism was launched in Dresden by a
bunch of students in 1905. The group called itself *Die
Brücke* (German for "The Bridge"), meaning they
wanted to be a bridge between the old and the new.
They drew their inspiration from Fauvism as well as from
medieval German woodcuts, primitive art, and the paint-
ing of Munch and van Gogh. Their work is characterized
by harsh and clashing colors, and tortured forms influ-
enced by African and Oceanic masks and fetishes. The
group held its first exhibition in 1906, moved its head-
quarters to Berlin in 1910 and disbanded by 1913.

WHO'S
H
O
☞

Die Brücke

Proclaiming that art was in need of renewal, Die Brücke welcomed anyone with a revolutionary turn of mind. Most of the group had no formal art training (as if they needed it!) and the vigor of their work barely survived the First World War.

Ernst Ludwig Kirchner (1880–1938).
Most inspired of the group, he sought to capture the harsh realities of modern urban life.

Karl Schmidt-Rottluff (1884–1976).
The harshest Expressionist, he was known for his woodcuts.

Erich Heckel (1883–1970).
A pessimist, he specialized in sickness and anguish.

Emil Nolde (1867–1956).
The rare professional in the gang, his work evinced a personal and national mythology.

Max Pechstein (1881–1955).
Most popular of the group, he painted flower pictures and portraits.

You don't have to be told that when it comes to expressing themselves, women take second place to nobody. The German expressionists had two great forebears of the female persuasion. Käthe Kollwitz (1867–1945) was arguably one the century's leading political artists, celebrating the nobility of working people

and taking up themes of pacifism and the tragedy of war. The wife of a doctor, she lived in the poor part of Berlin. She made her first big splash with two etching cycles, the *Weaver's Uprising* (1894–98) and the *Peasant's War* (1902–08). She became the first woman member of the Prussian Academy in 1929, holding the post until 1933 when the Nazis then expelled her and banned her from all public activity.

Paula Modersohn-Becker (1876–1907) started her career as a member of the late nineteenth-century movement called *Naturlyrismus* (German for "lyrical interpretation of nature"). After coming into contact with the Postimpressionists in Paris in 1901, she developed her own personal version of Expressionism. Her paintings of landscapes, still lifes, and mothers and children are characterized by a primitivistic simplicity of form and the attempt to develop what she called a "runic script" to express her inner feelings. Her early death at age thirty-one inspired her pal, the Symbolist poet Rainer Maria Rilke, to write his *Requiem for a Friend.*

Down in the south of Germany a more mystical Expressionism was brewing. Beginning around 1906, a broad group of artists made up what is now called *Der Blaue Reiter* (German for "The Blue Rider"). The movement was officially launched in 1911 and was named after a 1909 painting by Wassily Kandinsky. Unlike the group called Die Brücke, the Blue Riders didn't really have a single artistic program. Instead, the group embraced all advanced art activities, organizing exhibitions and publishing its own journal. Its first show, in 1911–12, featured forty-three works and toured Germany; a second exhibition of new graphic art included 315 works. The group disintegrated with the death during World

The Blue Rider

A mystical search for spiritual truth beneath the surface of nature was common to most of the circle of artists associated with Die Blaue Reiter, whose manifesto was written by Kandinsky and Franz Marc in 1912. Many artists from other countries showed with them, including Paul Klee from Switzerland, Kasimir Malevich from Russia and Delaunay, Derain, and Vlaminck from France. Some leading German members, in addition to Kandinsky:

Franz Marc (1880–1916).
Paintings of blue horses and yellow cows sent a message of pantheistic harmony.

August Macke (1887–1914).
Sensuous, calm, and colorful pictures from Tunisia and along the Rhine.

Gabriele Münter (1877–1962).
Kandinsky's pupil, her works combined bright colors with naiveté.

Heinrich Campendonck (1889–1957).
Dreamy abstractionist who made woodcuts and stained-glass windows.

Alexej von Jawlensky (1864–1941).
Actually a Russian, he moved to Munich and painted schematic faces.

Lyonel Feininger (1871–1956).
Maker of satirical drawings as well as cool, Cubist-influenced scenes of architecture.

War I of two of its leading members, Franz Marc and
August Macke.

KANDINSKY AND KLEE:
ANGLES AND SMUDGES

Wassily Kandinsky was a mover and shaker. Born in
Russia in 1866, Kandinsky was on his way to becoming
a lawyer when he discovered Impressionism at a 1895
exhibition in Moscow. He moved to Munich in 1896 and
proceeded to launch a series of art groups, including
the Phalanx group (1901), the Neue Künstlervereini-
gung (1909) and Die Blaue Reiter (1911). At the out-
break of World War I, it was back to Russia, where he
became an art commissar after the Revolution, organiz-
ing museums and founding the Academy of Artistic Sci-
ences. When it got hairy there in 1921 he split to
Germany and became a teacher at the Bauhaus, the fa-
mous art school that operated first in Weimar and then
at Dessau. After the Nazis took over in 1933, Kandinsky
went to Paris, where he lived for the rest of his life.

As a painter he started out making bold Expressionist
landscapes and country scenes influenced by Russian
folk art. But by 1910 or 1911 he had produced his first
abstract works, animated and colorful combinations of
circles, lines, squares, and other simple shapes. Over the
years his abstract vocabulary broadened and became
more complex, including a variety of signs, hieroglyphs,
and ornamental shapes. One of his mature works is *Com-
position 8* (1923) (see fig. 9.4), a work painted not long
after he left Russia. With his abstract "compositions"
and "improvisations," Kandinsky took his cue from
music and sought to distribute geometrical elements

9.4 *Inspired by music, Wassily Kandinsky made "improvisations" such as* Composition 8 *(1923) that use geometric shapes and vivid colors to evoke emotional states.*

across the canvas the way tones and motifs are distributed through a musical score. To Kandinsky, circles and triangles were evocations of the spiritual, inner life of man. In the painting he strives to impose pictorial reason on emotional experience. Kandinsky wrote two great theoretical treatises, *Concerning the Spiritual in Art* (1912) and *Point and Line in Relation to Surface* (1926), and also created woodcuts, frescoes, and stage designs and costumes for composer Petrovich Mussorgsky's *Pictures at an Exhibition* in 1928.

The Swiss-German master of poetic fantasy Paul Klee (1879–1940) was the rare twentieth-century master who actually studied art from the get-go, making engravings in his early twenties. In 1912 he participated in the third

Blaue Reiter show in Munich, but it was only after he had visited Tunisia in 1914 that he became "possessed by color" and decided that he was a painter. Like Kandinsky, he began teaching at the Bauhaus in 1920 and was eventually chased out of Germany by the Nazis in 1933. He returned to Bern, where he lived for the rest of his life.

Known for his enchanted, childlike pictures of stick people, poetic birds, and intimate checkered abstractions, Klee was the temperamental opposite of Kandin-

WHO'S WHO ☞

The Viennese

The epic of early twentieth-century Expressionism would not be complete without the Viennese, who seem to have a taste for artistic decadence and neurotic, agitated line. The big three:

Gustav Klimt (1862–1918).
Jugenstil master whose incredibly ornamental works addressed romantic themes of love and life.

Egon Schiele (1880–1918).
Erotic draftsman of emaciated nudes who spent twenty-four days in jail for his "pornographic" art.

Oskar Kokoschka (1886–1980).
Known for penetrating psychological portraits and agitated, moody landscapes.

sky. He had no studio and worked on a kitchen table, where he made small-scale drawings, watercolors, and etchings in a variety of experimental techniques. Always filled with cosmic symbols as well as abstract marks, his work abandons its playful and harmonic quality toward the end of his life and becomes more ominous and poetically frightening.

MODIGLIANI: A BANG-UP BOHEMIAN

The painter Amaedeo Modigliani had a life right out of a Harlequin romance. His mom encouraged him to be an artist, and he went to Paris in 1906. Handsome and temperamental, he hung out at cafés and lived in extreme poverty, wasted by drugs, alcohol, and the tuberculosis that would eventually take his life in 1920. The day after he died, Modigliani's devoted common-law wife, Jeanne Hébuterne, committed suicide by throwing herself out of a window. She had born Modigliani a daughter and was about seven months pregnant at her death.

She had also posed for many of his works. Modigliani specialized in mannered nudes, simple and sensuous, influenced by Brancusi and tribal art. He knew how he liked them, skinny and naked, just like Hugh Hefner. In 1917 Modigliani was even censored by the Paris police, who closed a gallery exhibition of his nudes for obscenity. Modigliani is called a School of Paris artist, which means he didn't really belong to any movement but was active in the Paris art vanguard after World War I. Other School of Paris artists include Moïse Kisling (1891–1953), Chaim Soutine (1894–1943), Jules Paschin (1885–1930), and Marc Chagall (1887–1985).

SUMMARY

⏱ Inspired by van Gogh and Gauguin, the Expression- ists used bright colors and jarring shapes to express their inner feelings.

⏱ Les Fauves are bright and full-bodied but not neces- sarily nasty.

⏱ Der Brücke is primitive and jarring—as far as beauty and harmony goes, forget it!

⏱ Der Blaue Reiter is colorfully cosmic and led to the first abstractions.

CUBISM

YOU MUST REMEMBER THIS

Cubism was the first totally abstract art movement—it broke all the rules artists had followed since the Renaissance.

BEST KNOWN FOR

Instead of making art that was representational, like a view through a window, Cubists looked cross-eyed through a kaleidoscope, suggesting their feelings through neutral color and geometric forms.

CUBISM: A CROSS-EYED LOOK AT THE MODERN WORLD

Cubism is certainly one of the weirdest art styles. You look at a Cubist painting and it's just a bunch of lines and planes and dabs of color. But then it has a title like *Still Life with Fruit Bowl.* Is this a joke or what?

Rub your eyes and try again.

Although Cubist paintings appear indecipherable at first, with a little looking they actually do make sense. And after a while longer you can see why the Cubists shook the art world like Einstein's theory of relativity shook physics. Influenced by current developments in science, music, and philosophy, Cubists tried to create a new language of representation, a new way of seeing things.

HOW IT ALL BEGAN

Cubism was created almost entirely by two men: Pablo Picasso and Georges Braque. Both were well-established avant-garde painters in Paris around 1907 when they first began to paint in the style that was later dubbed Cubism (neither of them called themselves Cubists). Although Picasso is the more famous, Braque is generally credited with starting down the road to Cubism first.

The principal influences on Cubism were the paintings of Paul Cézanne and African art. Around 1907, Braque was laying the groundwork for Cubism with an amazing series of abstract landscapes in a Cézannesque style. Cézanne had just died, and in 1907 the big ticket in Paris was a memorial exhibition of his work. Meanwhile,

WHO'S WHO ☞

All the world's a square. But what do you expect if you rule out luscious color, sexy subject matter, shapely form or dramatic light? Old masters on acid. Major artists:

Pablo Picasso (1881–1973).
The head honcho of modern art. Not only outlived everybody else, but had four wives, five styles, and a big house in the country.

Georges Braque (1882–1963).
Often slighted as Picasso's tagalong sidekick, but when this guy was good he was great. Never the same after injuries in the Great War.

Juan Gris (1887–1927).
Picasso's neighbor and probably the only other artist, besides Braque, who really understood Cubism. Painted lots of still lifes.

Fernand Léger (1881–1955).
Robo-Cubist. Master of mechano-men, figures made up of tubes and cubes. Liked to paint workers.

Constantin Brancusi (1876–1957).
Romanian modernist, invented streamlining.

Picasso, the child prodigy, was still working through his Blue and Rose periods (so-called for the predominant tonalities of these sappy Symbolist paintings of clowns and sad-eyed drinkers). From Cézanne, both Picasso and Braque picked up the idea of using geometric elements

as the building blocks of form: you know, a sphere for a body, a cone for a neck, a block for a head. This early tendency toward Cubism can be seen in Braque's landscape called *Road Near L'Estaque* (1908). The trees are bare curves, the road's retaining wall is an almost vertical zigzag, and the hills are shaded with regular, striated lines. In other words, the seeming naturalness of a realistic picture is replaced by a clearly invented version of the scene, which is emphasized by the picture's overall pattern of lines and shapes.

At the same time, African masks and fetishes (an object with magical properties, like a voodoo doll), just imported from European colonies, were beginning to turn up in European fleamarkets, junk shops, and anthropology museums. They were pretty exciting to Picasso, Braque, and their *amis*. Artists liked the expressive power of these masks and hung them in their studios right alongside their casts of classical sculpture. (Hey, they were artists not interior decorators!) Since African art was both abstract and vaguely realistic, it evoked the mystery and magic of non-Western rituals. These artists

THE NAME GAME

First rule of avant-garde art: If the critics hate it, you're in; if they give it a funny name, you're in the history books. Cubism was originally a derisive term, coined by critic Louis Vauxcelles, who, in a review of Braque's show at Galerie Kahnweiler in 1909, referred to the paintings as *Bizarreries cubiques* (French for "wacky cuby things"). This guy had a way with monikers: he also coined the art styles of Fauvism and Expressionism.

were not politically correct: they loved the fact that such icons were wrenched from their original cultural contexts and suggested exotic sterotypes of Africa.

When Picasso combined Cézanne and African art he came up with what is often considered the first Cubist painting: *Le Demoiselles d'Avignon* (1907) one of the ugliest paintings ever. This painting is so ugly that when Picasso had it in his studio he used to keep a blanket over it. But it's important because it marks a tendency toward abstraction and away from a strictly realistic or imitative way of painting the world. That's lucky because this painting shows five naked prostitutes, two of whom have African masks for heads.

For Braque, though, it was a breakthrough experience, like seeing *The Rocky Horror Picture Show* for the first time. He knew something fantastic was going on. So, he glommed onto Picasso and they started working together every day. They lived side by side, they took vacations together, they showed each other their newest Cubist experiments. Braque said they were "like two mountaineers roped together." As you might guess, their paintings started to look alike, and, for a while, they even stopped signing them. Braque said, "[We wanted] to efface our personalities in order to find originality." Today, art historians are still getting migraines trying to sort out who did what.

Cubism is divided into two phrases: Analytic and Synthetic. First came Analytic Cubism, in which the artists tried to depict a thing from many angles at once. An Analytic Cubist picture looks basically like a stew of angles and planes floating in brownish gravy, garnished here and there with something recognizable like an eye or a pipe. As an art style, it lasted from 1909 to 1912,

more or less. A good example is Picasso's *Portrait of Daniel-Henry Kahnweiler* (1910) (see fig. 10.1.). Kahnweiler was Picasso's dealer and in this portrait he is shown, barely recognizable, with his hands in his lap, a bottle on a table to his right, and an African mask on the wall behind him. He is shown from many points of view simultaneously and different parts of his body become different angles. He's all there but you have to be creative, squint, and imagine you're looking at him through stained glass.

Synthetic Cubism, on the other hand, builds up a picture from a combination of abstract signs and visual elements. A Synthetic Cubist picture looks like a collage of brightly colored junk flattened by a steamroller. Probably the most famous Synthetic Cubist picture is Picasso's 1921 *The Three Musicians* (see fig. 10.2). This work makes no attempt to replicate the actual visual appearance of a scene, but instead invents the image through almost arbitrary shapes and colors, flat cutout shapes, hierarchical scale (look at the tiny hand of the musician on the left), and inverted perspective. With no intention of imitating a three-dimensional scene on canvas, Picasso uses the two-dimensional building blocks of design as playthings for his whimsical (what are those costumes?), self-mocking (check out the faux Cubist wallpaper) composition.

Still wondering about the two Cubisms? Think of it this way: Analytic Cubism makes an abstract depiction of the real world; Synthetic Cubism uses bits of the real world to build up a new representation.

Between the two of them, Braque and Picasso made hundreds of Cubist paintings and collages, most of them still lifes and portraits. Picasso, ever the virtuoso, out-

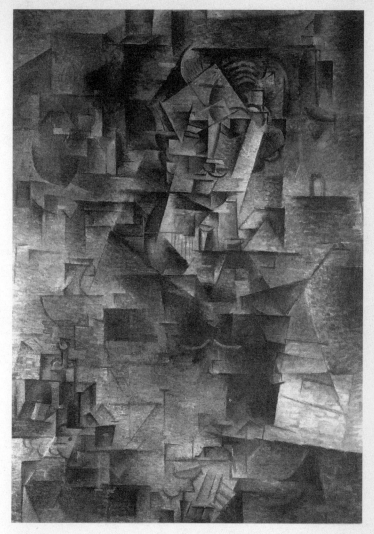

10.1 *Squint. Picasso's Analytical Cubist* Portrait of Daniel-Henry Kahnweiler *(1910) shows his dealer as if seen through a faceted window.*

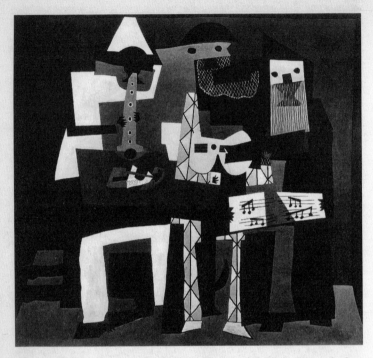

10.2 *Brightly colored junk flattened by a steamroller: Picasso's Synthetic Cubist masterwork* The Three Musicians *(1921) is based on principles of collage.*

painted the more deliberate Braque by about three to one. After Braque was beaned by shrapnel in World War I, he was never the same again. But Picasso remained inventive until his death in 1973.

THE INVENTION OF COLLAGE

One big invention of the Cubists was collage, the practice of adding stuff from the real world to their pictures. Picasso and Braque started innocently enough, stenciling letters in their paintings around 1910. But soon they were adding sand, rope, paper, and anything short of roadkill to their artworks. In 1912, Braque invented *papier collé* (or "glued paper"), using cut-out bits of decorative paper or words or images clipped from newspapers or sheet music. In *Guitar, Sheet Music and Glass,* 1912 (see fig. 10.3), Picasso used old wallpaper, fake wood-graining, and colored papers to simulate a guitar; the soundhole of the guitar is just a cutout circle. Active elements—music, drinking, and current events—are suggested by scraps of sheet music, newspaper, and Picasso's own Cubist drawing of a glass. In other collages, Picasso actually glued pieces of rope or imitation chair caning to the canvas.

Later, real objects were stuck to pictures. Fernand Léger put a mirror in his 1912 collage *The Washstand.* Soon everybody was incorporating real objects into their art, and, as the century progressed things stared to get out of hand. The Russian Constructivist Vladimir Tatlin used scraps of sheet metal in his reliefs around 1914; the Abstract Expressionist Jackson Pollock dropped ciga-rettes in famous drip paintings of 1947 and didn't seem

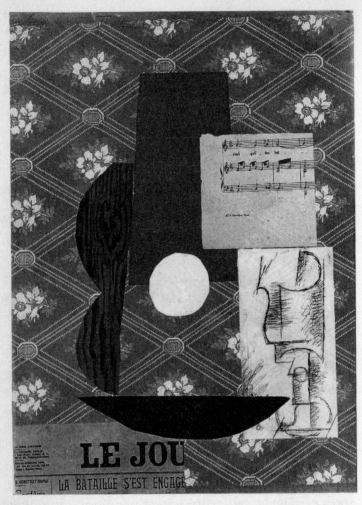

10.3 *Tired of painting alone, Picasso and Braque started fixing real objects to the canvas. Picasso's* Guitar, Sheet Music and Glass *(1912) uses old wallpaper, fake wood-graining, and colored papers to simulate a guitar.*

to care; and, in 1959, Robert Rauschenberg made a "combine painting" that incorporated a real stuffed goat with a tire around its middle. It was just a matter of time: road kill as art. See what the Cubists started?

THE MOTHER OF ALL MODERNIST STYLES

Cubism radically changed the way art was made and ushered in the notions of abstract art, art for art's sake, and modern art. Cubism's influence on artists and artistic styles as far away as Japan and Russia was profound and longstanding. Just a few of the movements inspired by Cubism were:

Rayonnism	Divisionism
Futurism	Constructivism
Expressionism	De Stijl
Cubo-Futurism	Orphism
Vorticism	Suprematism

More on these later.

BRANCUSI: STREAMLINE SUPREME

Although not strictly speaking a Cubist, the Romanian visionary Constantin Brancusi created an art of idealism and refinement that was clearly unleashed by the Cubist revolution. A cabinetmaker's apprentice, Brancusi arrived in Paris in 1904 and became a student of Rodin's. Ordinarily, a sculptor would make models from clay and then hire a professional stonecarver to do the heavy chopping. Not our Romanian.

By 1907 Brancusi was cutting directly into the stone himself, in search of "elemental shapes of universal beauty." Those are egg shapes, pebble shapes, and leaf shapes to you. He also drew inspiration from the wooden

porch pillars of Romanian peasant houses and is known for giving as much attention to the design of the bases for his sculptures as to the sculptures proper. Some of his notable works are *Beginning of the World* (1924), an ovoid marble shape that was designed for the blind; *Bird in Space* (1928), a soaring bronze shape that suggests swiftness; and the *Endless Column* (1908), a skyward soaring zigzag that the artist recreated in a 96-foot-tall version for Tîrgu Jiu in Romania.

GERTRUDE STEIN: AVANT-GARDE BIG MOMMA

The avant-garde writer Gertrude Stein (1874–1946) is popularly known for coining the phrase "a rose is a rose is a rose," whatever that means. She's also known for her "Autobiography of Alice B. Toklas" (1933), which is the story of her own life presented as that of her girlfriend and secretary. Stein was a big-time patron of the arts in Paris during its artistic heyday, holding soirees every Saturday that were major artistic networking events.

A Radcliffe grad who was born in Pittsburgh, Stein lived in Paris from 1903 until her death. She was a big supporter of Matisse and Picasso (he did a famous portrait of her in 1906), and collected art by everybody from Renoir and Gauguin to Toulouse-Lautrec and Maurice Denis. During the 1920s Stein hung out with expatriate American writers like Ernest Hemingway and F. Scott Fitzgerald, promoting their work and coining the term "the lost generation" to describe them. Her big brother Leo was also a major patron of Cézanne's.

CUBISM GOES WORLDWIDE

By World War I, Cubism was spreading faster than chicken pox in a kindergarten class. It had lots of practitioners besides Picasso, Braque, Gris, and Léger. The Dutch painter Piet Mondrian (1872–1944), who was in Paris from 1911 to 1914, took Cubism further than Picasso and Braque, inventing the abstract painting style known as Neoplasticism. In works such as *Composition* (1921) (see fig. 10.4), Mondrian tried to create emotional states through purely formal means, that is, by using only nonrepresentational line and color. This completely two-dimensional painting consists of balanced blocks of primary colors (red, yellow, and blue, plus white) connected by a lattice of black rectilinear lines. Mondrian hated curves so much that everything in his studio had only straight edges. Meanwhile, he had a secret vice. Without telling anybody, he continued to paint lush pictures of flowers.

Neck-in-neck in the race to invent the first totally abstract painting were the Frenchman Robert Delaunay (1885–1941) and the Czech artist Frantisek Kupka (1871–1957). Out of Cubism's drab right angles, these two created an abstract art consisting of interlocking circles and rings of bright color that the famous French poet and critic Guillaume Apollinaire dubbed Orphism. Orphism included one of the first great women avant-gardists, Sonia Delaunay (1885–1979). Born in the Ukraine, Sonia met and married her husband and artistic collaborator, the painter Robert Delaunay, in Paris in 1910. After his death, she continued painting and working as a fabric designer, receiving a retrospective at the

10.4 *Mondrian hated curves: his* Composition *(1921) consists of only blocks of primary colors (red, yellow, and blue, plus white) connected by a lattice of black rectilinear lines.*

Louvre in Paris in 1964—the first ever for a living woman artist.

But it was the Italians, led by the poet Filippo Tommaso Marinetti (1876–1944), who mixed Cubism and Impressionism and came up with Futurism, an anarchistic youth movement that celebrated speed and the machine. Futurism was especially good for depicting speeding cars, cancan dancers, and riots (see Umberto Boccioni's 1910 *Riot in the Gallery*), not to mention poodles on a leash. In Giacomo Balla's 1912 *Leash in Motion,* all the separate stages of movement seem to be happening at once.

Unlike Picasso and Braque, who were strictly "no comment" when reporters asked them what they were doing, the Futurists couldn't stop blabbing about their new movement. During the movement's brief life span, from 1910 to 1914, every Futurist had his own manifesto. The 1910 Futurist painting manifesto was signed by Boccioni, Balla, Gino Severini, and others. Boccioni's "Technical Manifesto of Futurist Sculpture," Luigi Russolo's "The Art of Noise," and Carlo Carrà's "The Painting of Sounds, Noises and Smells" all came out in 1912.

Even Marcel Duchamp, the self-styled Dadaist who would soon invent the "readymade" and plant the seeds of Conceptual Art (see chap. 11), went through a Cubist phase. His 1912 painting, *Nude Descending a Staircase,* caused a sensation at the 1913 Armory Show in New York City, the first big exhibition of modern art in the United States. This painting is almost Futurist in the way it shows the successive phrases of a woman's progress down the stairs. But American critics hooted when they saw it; one critic, unconvinced by Cubism, called the painting "an explosion in a shingle factory."

The end of World War I also brought a close to Cub-

ism's golden years, although Picasso continued to churn out masterpieces almost annually in a variety of new styles. One of his later styles, called Cloissonné Cubism, is exemplified by his famous *Girl Before a Mirror* (1932). In this work, Picasso shows off his virtuosity, arranging two equally schematic depictions into powerful decorative patterns of color, line, and shape. The woman is Marie-Thérèse Walter, Picasso's girlfriend at the time. Her image on the left is pink and blond with red lips, while in the mirror she looks distinctly more sinister, with a masklike face and hawk nose. Is Picasso, who is famous for loving and leaving the women in his life, suggesting that a mirror can magically reflect the inner self of the person who peers into it?

The haunting aspect of *Girl Before a Mirror* gives some indication of the turn art took between the wars: things got decidedly gloomier. In fact, this period seems to have ushered in modern art's dark side—seen first, and most notably, in Dada and Surrealism, and later in Abstract Expressionism and Neodada. To paraphrase Bette Davis, fasten your seat belts, folks, it's going to be a bumpy ride.

SUMMARY

🕰 Beginning in 1907 and continuing until the First World War, Cubism created the first abstract way to picture the world.

🕰 Analytic Cubism (1907–12) dissected reality from multiple angles. Synthetic Cubism (1912 and after) replaced pictures of real things with abstracted signs and symbols.

🕰 Pure abstraction in painting was developed simultaneously by Mondrian, Kupka, and Delaunay (not to mention Malevich in Russia, whom we'll meet in Chapter 11).

DADA, SURREALISM, AND CONSTRUCTIVISM

YOU MUST REMEMBER THIS

After the horrors of World War I, groups of artists and other beret-wearing hipsters were less interested in making pretty pictures than in challenging society.

BEST KNOWN FOR

Artists play hooky from art class: some get radical, some discover their inner child, some moon the audience.

DADA: WEIRD AND WACKY

J ust after World War I, the strange and unpredictable Dada movement sprang up simultaneously in several cities: Paris, Berlin, Cologne, New York, and Zurich. *Dada* means "hobbyhorse" in French, but basically it's a nonsense word, like *googoo*. It was meant as a response to highfalutin art movements with classy names. The Dadaists had had it with middle-class pieties; the war showed them

WHO'S WHO☞

The principal avant-garde movements of the 1920s were Dada, Surrealism, and Constructivism. Some leading artists were:

Marcel Duchamp (1887–1968).
Mounted a bicycle wheel on a stool and called it art; exhibited a urinal and called it a fountain; drew a moustache on the Mona Lisa and laughed.

Salvador Dalí (1904–1989).
Wacked-out dream imagery—melting watches and the like—all painted in a meticulous style.

Joan Miró (1893–1983).
Catalan pal of Hemingway who painted hallucinatory biomorphic abstractions.

Kazimir Malevich (1878–1935).
Master of the Russian art movement he called Suprematism. The original Op artist, he painted the nearly invisible *White on White*.

that the world was absurd and purposeless. They placed their faith in provocation. Dada was not a style so much as it was a fundamentally antisocial attitude. Dadaists were fervently anti-art, consistently shunning art works (including their own) in favor of anarchic actions. They liked to stage incendiary public events, such as readings of nonsense poetry, cabaret performances, and mock art

THE FIVE FACES OF DADA

Dada was an international phenomena in the days before E-mail. It took different forms in different cities, but all the "clubs" shared a common sense of absurdist cynicism and a barely concealed antipathy toward bourgeois society. This pre-punk anarchism was vented in five burgs.

Zurich Dada. It all began at the Cabaret Voltaire, a hip spot in 1916. While Tzara and Emmy Hennings shouted poems on stage, Lenin read a book on Marx in the corner.

Paris Dada. These guys made fun of everything, including nuns. Led by writers André Breton and Tzara (just in from Zurich), they published more than they exhibited.

Cologne Dada. Brief Dadaist interlude in 1919 was virtually limited to the work of Max Ernst, a first-rate provocateur who often attracted the cops to his shows.

Berlin Dada. These political Dadaists, including George Grosz, John Heartfield, Raoul Hausmann, and Hannah Höch, invented photomontage and made fun of the Nazis.

New York Dada. Here, the main pranksters were Duchamp, Picabia, Man Ray, Arthur Cravan, and a few others. Their big schtick: jokes on Manhattan art snobs.

exhibitions. Taking this chaotic approach to the ultimate extreme, Dada poet Tristan Tzara proposed making art by firing a pistol at random in a crowded street.

Despite such brainstorms, the Dadaists somehow managed to say out of jail and in the galleries. They even made art occasionally.

DUCHAMP'S BATHROOM FIXTURE

The prototypical Dadaist was Marcel Duchamp, a guy best known today for having drawn a moustache on a penny postcard of the Mona Lisa. Such kooky high jinks gave Duchamp his lifelong rep as a prankster. Many of his works make you question whether it's art or not. In 1917, he exhibited a urinal and called it *Fountain.* That angered a lot of people. But that was just one example of what Duchamp called the "readymade," something he invented by simply declaring an everyday found object to be a work of art. Among the artworks he created this way were a comb, a coatrack, and a snow shovel. To him, the local K-Mart was far more exciting than the Louvre.

Maybe Duchamp was just bored with painting. You see, art was the family business. Everyone in Duchamp's family was an artist, including his sister Suzanne, a Dadaist painter who also married an artist. His two brothers, printmaker Jacques Villon (1875–1963) and sculptor Raymond Duchamp-Villon (1876–1918), even changed their names so it wouldn't look like there were too many artists from the same brood. Marcel was the troublemaker in the family. Even before the pissoir incident, he had created a scandal by exhibiting his Futurist painting *Nude*

Descending a Staircase (1916) at the Armory Show in New York (see chap. 10).

After that, Duchamp gave up painting and started stirring up trouble with Dada factions in New York and Paris. His main interest was sex, and although there is no evidence he actually had sex himself, he explored the topic in a wide variety of very strange works. His masterwork is a totally bizarre construction on glass called *The Bride Stripped Bare By Her Bachelors, Even* (1915–23), or simply *The Large Glass* (see fig. 11.1). This looks like a large car-parts diagram on an oversized window pane. Supposedly it depicts the deflowering of a mechanical bride, but it's rather hard to see. Suffice it to say that the "bride" machine hovers somewhere in the top half, while the "bachelors" hang out in the lower half (see their penis-like shapes on the left). With all those pistons and drive shafts, it might have been steamy. But it's all so abstract that, unfortunately, it's not really that hot. What's worse, on the way back from its first showing, the truckers accidentally smashed it to smithereens. Unfazed, the obsessive Duchamp spent the better part of a year gluing all the tiny pieces together.

After this arduous labor of love, Duchamp "retired" from art making for the next forty years, living off the good graces of a variety of wealthy patrons. In secret, he was building his last great work *Etant Donnés* (1946–66), an installation that was only revealed after his death in 1968. This last piece, a sort of three-dimensional version of *The Large Glass,* is a peep show in which the viewer looks through two holes in the door to see a nude woman lying in a grassy landscape. Cool.

11.1 *A weird allegory of sex and gender, Marcel Duchamp's* The Bride Stripped Bare By Her Bachelors, Even *(1915–23) is an iconoclast's response to the overmechanization of the modern world.*

Dada Big Daddys

Despite their antiart protestations, the Dadaists were brilliant artistic innovators. Some of the most important Dada artists were:

Max Ernst (1891–1976).
One of the most eccentric and inventive Dadaists; made pictures by collage and frottage (rubbings made by coloring paper laid over wood grain to pick up the wood's pattern and texture). His alter-ego was a bird named Loplop.

Kurt Schwitters (1887–1948).
Made tiny collages from old bus tickets and other odd scraps of paper. His whole house was a vast, encrusted junk sculpture he called Merzbau.

John Heartfield (1891–1968).
Drove the Nazis crazy with his satirical photomontages showing the real story: Hitler taking money from capitalists and other follies.

Hannah Höch (1889–1975).
Berlin Dadaist and the mother of photomontage cut-and-paste.

Man Ray (1890–1977).
Important avant-garde photographer who took portraits of Parisian rich and famous. Invented the eponymous Rayograph, exposing objects directly on photo paper without using negatives.

SURREALISM: WEIRDER AND WACKIER

Many of the Dadaists, like Ernst, Man Ray, and Duchamp, were also involved in the Surrealist movement, which came slightly later. Surrealism was primarily a literary movement. It was led by André Breton, a writer and poet who was all excited about Sigmund Freud's ideas about the relationship between dreams and the unconscious. Breton even visited Freud in Vienna. For Breton, practices like free association, automatic writing, and dream narratives were self-revelatory routes to the unconscious. His idea was to unite the union of the seemingly opposed worlds of the conscious and unconscious in a higher—or at least truer—level of reality, which in 1917 he named *surreality*.

Breton really didn't have any idea how to connect this literary theory of the mind to art, but he knew what he liked. One of his favorite painters was the Italian Giorgio de Chirico (1888–1978); Breton saw his work in a shop window one day and he was forever after haunted by it. De Chirico was no dope either. He had his own theory regarding another reality, which he called "metaphysical insight." He claimed that all things had an inner, metaphysical dimension that, if you tried, you could glimpse occasionally, like in an X-ray. Uh huh. Kids, do not try this at home. De Chirico's plan was to spur this process through his paintings, to expose this other reality by placing normal objects in odd juxtapositions or just by pointing out the strangeness in the everyday. This did not involve psychedelic drugs.

You can get the idea from de Chirico's *The Enigma of the Day* (1914) (see fig. 11.2), a deserted piazza with two

tiny figures echoed by two large smokestacks in the background. Beyond the empty space, illogical shadows, and unexpected perspectives, everything seems portentous: the gigantic statue, the hypnotically repeated arches, the inexplicable furniture van parked in the square. In true Surrealist style, ordinary things are placed in mysterious relationships to each other. This mood is emphasized by de Chirico's simplicity of form and shading, which derives from Cubism, and by his crude, almost primitivist,

FREUD AS COLLECTOR AND CRITIC

Besides being the father of psychoanalysis and a major inspiration for the Surrealists, Sigmund Freud (1856–1939) was also something of an art collector. In his office he had dozens of ancient art works, ranging from an Egyptian statue of Isis to a Greek figure of a sphinx, part woman, part winged lion. He began collecting in 1896, after the death of his father and over the next forty years assembled some two thousand antiquities. It may seem curious to us today that he eschewed African art and also failed to buy contemporary work.

Freud also had a rather checkered career as an art critic, or rather, as an essayist on art. His principal foray into art writing, a study of Leonardo da Vinci first published in 1910, turned out to a major blot on his record. Freud wrote a totally nutty "psycho-biography" of Leonardo, claiming, among other things, that the artist's prophetic flying machines represented sublimated sexual desire and that Leonardo's lost painting *The Virgin and Child and St. Anne* was really a portrait of his family, with himself cast as the Christ Child. Freud also wrote a more sedate art study, *The Moses of Michelangelo*, in 1914.

11.2 *Giorgio de Chirico loved a good mystery: his painting* The Enigma of the Day *(1914), like a scene from a Hitchcock film, makes it seem like something's wrong downtown.*

style, which stems from the art of Duoanier Rousseau. But the disturbing dreamlike quality is all de Chirico.

MIRÓ, MIRÓ ON THE WALL

Joan Miró was born in Barcelona and always identified himself as a Catalan. He went to the local school of art,

THE SURREALIST ROSTER: WHO'S IN, WHO'S OUT

Beginning in 1924, Breton issued regular manifestos on Surrealism, spelling out the rules. He also determined who was in and who was out. But despite this dictatorial leadership, the Surrealists, like the Dadaists, were remarkably free-spirited.

Marc Chagall (1887–1985).
Fiddler on the roof. Painted Jewish folktales and theater scenes with bright color and a mixture of fantasy and abstraction.

Yves Tanguy (1900–1955).
Made tiny paintings that look like rocks or marine forms on a beach.

Réné Magritte (1898–1967).
This Surrealist in a bowler painted in a highly realistic style but often challenged the discrepancy between representation and reality.

Alberto Giacometti (1901–66).
Famous for his later sculptures of tall anorexic men, but his early Surrealist works of the 1930s are even more bizarre.

Meret Oppenheim (1913–89).
She made the fur-lined teacup. What more do you want?

copied local medieval frescoes, and drew his themes from local folklore. He was a good student and a stay-at-home kind of guy. But he busted out in a big way when he turned twenty-six: he went straight to Paris and fell in with the avant-garde. His best pal was Picasso, the only one around who spoke Spanish. On subsequent visits to Paris, Miró got involved with the Dadaists and the Surrealists and began painting weird, dreamy pictures. But even then, Miró was a good student. All his paintings before 1925 are incredibly meticulous, with skillful brushwork and smooth surfaces. They took him forever to paint; he made only one or two per year. Miró's painting *The Farm* from 1921 is a remarkably detailed recreation of his childhood home in Montroig; the scene is a combination of memory and fantasy. Hemingway loved the painting so much he bought it—even though he couldn't afford it—and took it right home in a taxi.

After 1923, something snapped. Miró was painting so slowly he had no money. And he was starving. Miró later said that he was so hungry he was constantly hallucinating. To put a little bread on the table, he developed an incredibly fast and breezy method of painting that he likened to poetry: a brushy one-color background, then just a few dots or lines to suggest an idea, feeling, or emotion. Voilá. A good example is *The Hunter (Catalan Landscape)* (1923–24), in which loosely drawn or biomorphic doodles are combined with letters and disembodied eyes to create a whimiscal panorama. On the left is a stick-figure hunter, holding a rabbit in one hand and a gun in the other. He has a beard, a pipe, and a triangle head. The geometric and calligraphic lines combine to unlock the creative forces of the collective unconscious and thereby encourage the spontaneous generation of

fantasy. This became the basis of Surrealist abstraction, a style decidedly at odds with the highly detailed dream pictures of Dalí or Magritte.

Perhaps the wackiest Surrealist, and certainly the most notorious, was Salvador Dalí, another Spaniard, and the artist who invented self-promotion. He had that long moustache, and he once dove through a plate-glass window at Macy's as a publicity stunt. But he also made some interesting paintings. He wanted to represent literally and exactly the images he saw in his dreams. So you got all the bizarre juxtapositions of his mental landscape presented with the precision of an illuminated manuscript. His most famous painting may be the tiny *The Persistence of Memory* (1931) (see fig. 11.3), the one with the melting watches. Dalí had a complex about impotence, and anyone who understands guy psychology knows those things aren't really watches. They allude to the penis. In any event, the watches are presented in a plausible landscape. But what is odd, aside from the limpness of the timepieces, is that they are being attacked by ants and a fly.

FROM RUSSIA WITH REVOLUTIONARY FERVOR

Working in Moscow, Kazimir Malevich was one of the first avant-garde artists to rid art totally of any reference to the natural world. His art was derived from Cubism but was purer. "The square is a living, royal infant," Malevich said about his work. "It is the first step of pure creation in art." He called his work Suprematism because he thought it captured the supremacy of pure feeling and pure perception. This distillation can be seen

11.3 *Time, time, time is on my side: Salvador Dalí's* The Persistence of Memory *(1931) gives substance to the bizarre unreality of our dreams. (Well, maybe his dreams.)*

in his *Suprematist Composition: Red Square and Black Square* (1915). It shows two, nonrepresentational geometric forms: a black square and a slightly off kilter and smaller red square. The purpose was to set up a dynamic relationship between the forms without referring to any object in the real world. Some of the works in the same series were more complex, containing many geometric elements, but others were as simple as a white square on a white background.

Constructivism developed in Russia around 1920 and described the work of abstract artists who opposed pure art or art for art's sake. They wanted art with a mission, art with a function. One criterion they used was authen-

ticity. This manifested itself in a desire for factual images in photography, tangible materials and textures in painting, and real space in sculptured reliefs. There was a split among the Constructivists over the question of social utility: Naum Gabo and his brother Antoine Pevsner favored an autonomous art; Vladimir Tatlin and Alexander Rodchenko favored a functionalist art. Tatlin even designed his own clothes.

SUMMARY

⏱ The avant-garde motto: Burn the museums, damn the patrons, everything is art. The avant-garde goal: Make art and life one.

⏱ Dada was against everything: war, middle-class society, the meaninglessness of modern life, and the traditions of art.

⏱ Duchamp, the ultimate Dadaist, invented the readymade, a found object that is given a new meaning as art.

⏱ Surrealism sought to liberate art from reason by exploring the unconscious and depicting the incongruous dream imagery.

⏱ Constructivism and Suprematism united abstract art with the political program of the Russian Revolution in an effort to create an ideal, utopian society.

ABSTRACT EXPRESSIONISM

YOU MUST REMEMBER THIS

Abstract Expressionism is about bigness: big wall-size paintings, big housepaint brushes, big sloppy drunks, big sublime themes, and big male egos. You get the idea.

BEST KNOWN FOR

Psychologically complex, Ab Ex is famous for the symbol-laden drip paintings of Jackson Pollock. Phrases commonly heard among the Abstract Expressionists: "Everyone we know is completely mental" and "A guy walked into a bar...."

DEPRESSION PAINTING

Abstract Expressionism had its roots in the 1930s, the decade of F.D.R., the Dust Bowl, and the Great Depression. Nothing is more depressing than the Depression. Almost everyone was depressed and broke, especially artists. One down-on-his-luck painter was so hungry he ate boiled shoe leather, just like Charlie Chaplin in *Gold Rush.* But the government came to the rescue with the Works Progress Administration (WPA), a quasisocialist public assistance program that included a division called the Federal Arts Project that was devoted solely to artists.

The WPA sponsored more than twelve hundred murals in public places. Unfortunately, most of them were really bad; you may have seen one in your local post office, if it hasn't been painted over. Arshile Gorky called it "poor art for poor people." But it was a practical solution to a national crisis and helped a lot of artists survive.

Although much of the WPA art was figurative and based on the fairly traditional Social Realism of American Regionalists like Thomas Hart Benton and Grant Wood, it was also very political. Many of the artists were influenced by the social protest art of the Mexican muralists, especially José Clemente Orozco, David Alfar Siqueros, and Diego Rivera, whose 1936 mural for Rockefeller Center was destroyed because its themes were politically too risqué.

EARLY ABSTRACT EXPRESSIONISM

There were two phases of Abstract Expressionism:

FRIDA KAHLO
. .

One of the great enthusiasms of recent art history—and of the rock star Madonna—has been the obsessive autobiographical work of the Mexican painter Frida Kahlo (1907–54). Her life was like a soap opera. Horribly injured in a bus accident as an adolescent, Kahlo had to undergo numerous operations during her life on her spine, pelvis, and right leg. A committed Marxist who was dedicated to Mexican independence, she married Diego Rivera, a larger-than-life figure who was not the best husband in the world. She had frequent miscarriages and abortions, never successfully bearing children.

Kahlo dealt openly with such subjects as female oppression and victimization, until then taboo in contemporary art. Many of her works are self-portraits that include symbols from Christian and pre-Columbian iconography, as well as images emblematic of her troubled personal life. Bleeding hearts, thorn necklaces, monkeys, black cats, dragonflies, tropical foliage and flowers, stone idols, and drops of milk falling from the sky are just a few of the haunting images that give her work its magic.

Early (c. 1930–45) and Classic (c. 1946–60). Early Abstract Expressionism was influenced by European modernist styles, mainly Cubism and Surrealism. This unwieldy combination is clear in a painting like Arshile Gorky's *Garden in Sochi* (1941), an abstract depiction of the artist's childhood home in Armenia. From Cubism, Gorky took the idea of making the figures and objects in his paintings look completely flat, brightly colored, and abstract. From Surrealism, he borrowed concepts derived from psychoanalysis: automatism (just close your

eyes and doodle); free association (hey, that doodle re-
minds me of a cow, which reminds me of . . .); and the
collective unconscious (we all have the cow gestalt,
man).

In Gorky's and other artists' works, the combination
of these two styles produced an amazing array of formal
innovations: overblown scale, nearly monochromatic
painting, use of unconventional materials (housepaint),
and a content based on myth and memory. The main
artists of Early Abstract Expressionism included Arshile
Gorky (1904–48). He was a melancholic Armenian refu-
gee whose work combined Miró, Picasso, and Kandinsky.
No jokes here. This hard-luck case committed suicide by
hanging in 1948.

Hans Hofmann (1880–1966) was an influential painter
and teacher who had studied at the Bauhaus. He taught
class in Provincetown on Cape Cod.

Stuart Davis (1894–1964) was an American Cubist who
used flat graphic forms in bold colors and references to
brand-name products to create a sort of pre-Pop art.

WHAT'S IN A NAME?

The phrase *Abstract Expressionism* was first used by Wassily Kandinsky in Germany in 1919, but was revived by American art critic Robert Coates in 1946. Like most labels dreamed up by art critics, Abstract Expressionism made no sense when applied to American artists of the 1940s: not all the work was abstract and most of it wasn't very expressionist. Harold Rosenberg called it "action painting" (arguing that the process was the content) and others referred to the *New York School* or the *New American Painting*, but Abstract Expressionism stuck. Of course, the French had to be different and named the style *tachisme*, which means, essentially, blobs of color.

CLASSIC ABSTRACT EXPRESSIONISM

Abstract Expressionism celebrated the angst-ridden individual, making that artist's struggle toward creativity seem both dramatic and heroic (which it usually wasn't). For the Abstract Expressionist, art could liberate the soul of the isolated individual in a messed-up world. Many of the artists relied on classical myths and non-Western art (including Native American and Inuit masks) to stimulate collective memories and evoke universal truths. Basically, it was the Men's Movement of the 1940s and 1950s, without Iron John.

But it wasn't all brainy stuff. There was a lot of hanging out in bars like the Cedar Tavern, driving fast cars, and listening to beatnik poetry and jazz. And once they got in their studios, the Ab Ex painters were not all of one mind. Actually, their styles were quite diverse, rang-

ing from Rothko's floating rectangles of color to de Kooning's figurative slasher paintings. During the Classic phase, after World War II, there were two main forms of Abstract Expressionism: gestural painting and color-field painting.

Gestural painting was basically what it sounds like: Artists wildly slapping paint on huge canvases. In his famous

WHO'S
H
O ☜

Action painting—slashing, dripping, and flinging paint and cigarette butts on canvas. These guys were totally regressive, like kids who never cleaned their rooms and got away with it. Action painting was about acting without thinking too much, being "in" the painting while painting it. Major artists:

Jackson Pollock (1912–56).
Made for Hollywood—balding cowboy type hates mom, but likes pissing from rocks and dripping paint on canvas. Hello? Paging Dr. Freud.

Willem de Kooning (b. 1904).
After Pollock, de Kooning is the major guy. Switched from brushy abstractions of the late 1940s to wicked paintings of smiling demon women in the fifties.

Mark Rothko (1903–70).
Brooding floating rectangles of abstract color on large canvases. There's a chapel full of these things in Texas. Contemplate the void, man.

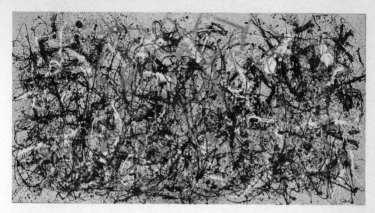

12.1 *Jack the Dripper. Jackson Pollock flung and poured housepaint directly from the can to produce* Autumn Rhythm *(1950), a surprisingly lyrical evocation of nature.*

drip paintings such as *Autumn Rhythm* (1950) (see fig. 12.1), Pollock applied ordinary house paint to the canvas while it was lying on the floor. Pollock built up the turbulent surface of abstract lines until the canvas came alive in a texture of forms and rhythms. Clearly, the painting is not supposed to represent something (as with Gorky's pictograms) but is meant to evoke a feeling or sensation. When asked if his title meant he was painting from nature, Pollock replied, "I am nature!"

Pollock and de Kooning were accepted masters of the gestural style, but there were others.

Robert Motherwell (1915–91) was a brainy abstract painter known for his large collages and extended series of abstract paintings called "Elegy to the Spanish Republic" (1949–76).

A clue about Franz Kline's (1910–62) big paintings with calligraphic stripes of house paint: they're not as

spontaneous as they look. Two words: overhead projector.

Since Lee Krasner (1911–84) was married to that drunken crybaby Pollock, she never got her due. But some of her abstract paintings—swooping arabesques of Cubist-inspired forms and colors—are better than his.

Then there were the Abstract Expressionists who painted large fields of color, literally. One guy, Barnett Newman (1905–1971), made a painting that's eighteen-feet long and almost entirely red, except for some little thin stripes called zips. Others just made ragged abstract shapes or washes of color. Most famous is Mark Rothko, whose work is typified by floating masses of color that are like huge square clouds or shadows; they don't represent these things, but they conjure up similar moods—sadness, nostalgia, enigma.

Clyfford Still (1904–80) was from the West Coast and painted large canvases with craggy shapes of earth color and gave them titles like *1954–H* and *1955-K.* Adolph Gottlieb (1903–74) made mythological painting of pictograms in boxes. He later painted floating blobs or bursts of color—very abstract.

In the 1950s, many artists like Willem de Kooning attempted to turn abstraction back to its figurative roots and to produce Abstract Expressionist figurative paintings of people. Few were as successful as de Kooning, however. His series of abstract depictions of women—such as *Woman and Bicycle* (1952–53) (see fig. 12.2)—combined slashing brush strokes with a vague suggestion of naturalism to create a frightening image of the fair sex. These pictures always contained garish red lips, often parted to reveal ferocious teeth. One painting even used a collage of Marilyn Monroe's lips.

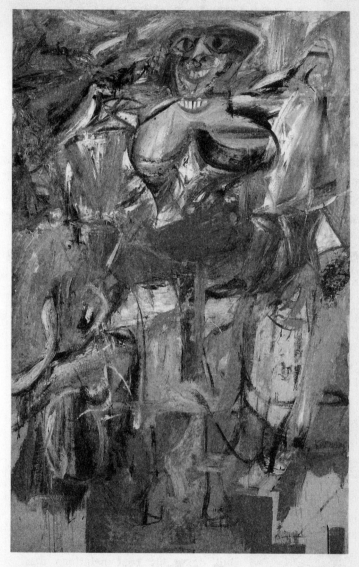

12.2 *After years of painting abstractions, Willem de Kooning returned to figuration with his "Woman" series, including the frightful* Woman and Bicycle *(1952–53).*

ABSTRACT EXPRESSIONIST SCULPTURE

It makes sense that if painters were flinging housepaint around someone would come up with the idea of casting, welding, or taping together junk. Although often very different in appearance, David Smith's sculptures embody many of the characteristics of Abstract Expressionist paintings. Employing a combination of Cubist and Surrealist motifs, Smith made large, abstract, welded-steel sculptures such as *Hudson River Landscape* (1951). These works often depict actual scenes or

WHAT A WAY TO GO

Let's face it, there's something suspicious about the mysterious and untimely deaths of so many Abstract Expressionists. It's like that JFK thing. Conspiracy or coincidence? You be the judge.

Arshile Gorky. After a car accident, he hung himself in a barn in 1948.

Jackson Pollock. Smashed into a tree while driving drunk and speeding in 1956.

David Smith. Died in a truck accident on an isolated country road in 1965.

Mark Rothko. Said to be a slit-wrist suicide in 1970, although some say he was murdered.

Willem de Kooning. Not legally dead, but doing his best paintings after being declared senile and made a ward of his daughter in 1989.

Willem de Kooning (1904–)

persons in highly abstract ways and look like enlarged steel versions of Smith's drawings—which they were. The junk sculpture caught on, though driftwood came later. The Ab Ex sculptors still had some subliminal memory of European high-art sculpture, so their work is fairly orderly and abstract even if it does employ crazy materials and themes.

David Smith (1906–65) was a burly welder who once worked on an auto assembly line. He made abstract sculptures of boxy shapes (called *Cubis*) or forms made out of tools. His motto: If it's out in the barn, weld it together.

Tony Smith (1912–80) was an architect and sculptor who made very abstract geometric shapes. He is best-known for an eight-foot cube called *Die.*

Louise Bourgeois (1911–) is considered the grande dame of American sculpture. She made pre-feminist drawings and sculptures of women and houses in the 1940s. She is best known for her sexy sculptures and installations of the postmodern 1980s, though.

Louise Nevelson (1899–1988) made abstract wall assemblages of wooden boxes and other junk, all painted black.

Joseph Cornell (1903–73) was the master of the Surrealist box. This Utopia Parkway (Queens, N.Y.) shut-in made beautiful shadow boxes filled with Victorian ephemera: toys, birds, stars, and ballerina dolls.

COLD WAR SPOOKS PROMOTE MODERN ART

In the Cold War atmosphere of the 1950s, Abstract Expressionism—minus its roots in social protest—was

promoted abroad as a political symbol for the individuality so prized in American culture. In fact, the conservative *Life* magazine heralded Pollock as "the greatest living painter" and the CIA staged exhibitions of Ab Ex paintings. Ab Ex has been called the triumph of American painting, because after 1945, American artists, who were generally considered rubes, finally started to get some international respect. This development virtually assured the shift of the art world from Paris to New York in the 1950s, so there were a lot of moving expenses for anyone on the continent who felt like hanging with the in-crowd.

ABSTRACT EXPRESSIONISM ABROAD

One sign of respect for the Abstract Expressionists was the way their work was copied in other countries, particularly in Europe and Latin America. In France the style was called *tachisme*, *art autre*, or *art informel*; among the French Abstract Expressionists were Georges Mathieu, Jean Dubuffet, Hans Hartung, Henri Michaux, and Wols (he only had one name, like Prince or Madonna). The group called COBRA, active from 1948 to 1951 in Copenhagen, Brussels, and Amsterdam (get it?), included painters like Asger Jorn and Karel Appel, who made brightly colored, expressionist canvases. And in Canada, there was even a bit of Ab Ex in the groups called Refus Global (led by Paul-Emile Borduas) and Painters Eleven. (After their leader Oscar Cahén died in a car accident in 1956, there were ten.)

SUMMARY

⏱ After World War II, avant-garde art left Paris, where it had resided for centuries, and moved to New York (where it remains to this day).

⏱ Early Abstract Expressionism enlarged and simplified the European styles of Cubism and Surrealism.

⏱ Classic Abstract Expressionism got even bigger and bolder, heroic even, to match the U.S.'s Cold War importance.

⏱ Artists took on the image of tortured geniuses.

POP, MINIMALISM, AND BEYOND

YOU MUST REMEMBER THIS

With Pop art, American mass culture was celebrated in recognizable images of everyday consumer icons. But subsequent art styles became increasingly hermetic until conceptual art eliminated the art object altogether.

BEST KNOWN FOR

Pop culture made me do it. Then, TV made me do it. Then MTV made me do it again, faster. The art work shrinks down to nothing and then comes back again.

FROM ADS TO FADS

Postwar art throughout the world was formed almost entirely in response to the rise of American mass culture. Television, Hollywood movies, photoweekly magazines, billboard advertising, fin-tail automobile design, and an explosion of consumer products made former distinctions between high and low art virtually impossible. And rather than buck the tide, artists jumped in feet first, enthusiastically taking the objects of everyday life as their subject matter. Pop (for *populist*) art derived from a rejection of the conventions of high art and traditional forms of art making. Suddenly, artists were making beer cans and soup cans and pictures from comic books and sculptures from giant hamburgers. For these Pop artists, the supermarket was their art school. This new art was populist in that it was representational and comprehensible. And people loved it. After fifty years of being the bad boys of society, artists were popular with the mainstream.

Pop art actually began as an anarchic protest against the dogma of individualism that marked Abstract Expressionism. In 1953, Robert Rauschenburg went so far as to erase a drawing by Ab Ex hero Willem de Kooning. If this sounds a lot like something Marcel Duchamp would have done, it is. In fact, the early, proto-Pop artists are often called Neodada because their works revive earlier Dada attitudes. They favored chance as an organizational principal, railed against self-expression, used objects in their work, and argued for the reconciliation of art and life. The best known of the early Neodada artists are Jasper Johns and Robert Rauschenburg, who were pals in the 1950s.

WHO'S WHO☞

Jasper Johns (b. 1930).
Flags, targets, and grade-school graphics with numbers and colors.

Robert Rauschenberg (b. 1925).
Revived Dada by erasing de Kooning; ran out of canvas so he painted his bed.

Andy Warhol (1928–87).
Celebrated banality and boredom in the form of soup cans, movie stars, and electric chairs. Invented the superstar and became one himself.

Roy Lichtenstein (b. 1923).
Comic book copycat became the master of the Benday dot.

Robert Smithson (1938–1973).
Earth artist whose mounds and monuments culminated in a spiral jetty built in Utah's Great Salt Lake. He died in a helicopter crash while inspecting one of his works, a giant curved asphalt ramp in Amarillo, Tex.

Johns, the more literary of the two, made paintings that used irony, puns, and word play. Rauschenburg's work was more involved with variety, openness, and found images. Unlike the Abstract Expressionists, who were bound to nature and psychology, Johns and Rauschenburg dealt almost exclusively with the cultural or manmade. They were inspired by the example of Du-

champ's readymades and shared his fascination with things that already existed in the world. Their works were more actual objects than pictures of objects.

Robert Rauschenburg came from Port Arthur, Texas (as did Janis Joplin). In the 1950s, he lived near the New York seaport, in the same building as Jasper Johns. Rauschenburg wandered around at night collecting scraps and detritus to include in his art works. He conceived of painting as a procedure rather than a depiction of nature or reality. The artwork itself was reality. Rauschenburg regarded his works as shop projects— things to be assembled or constructed. He called these works *combines* because they combined painting and miscellaneous found objects.

One of Rauschenburg's works had a chicken on the top of it, another had a pillow hanging from it, a third contained a life-size stuffed goat with a tire around it. Others contained collaged photographs, newspaper items, clocks, road signs, rope, and odd bits of junk. But perhaps the most outrageous, was his *Bed* (1955), in which paint is slathered over the sheets, quilt, and pillow from Rauschenburg's own bed. It is as though, after a night of feverish painting, the artist's soiled bedclothes were simply hung on the wall. Rauschenburg always said he wanted to "act in the gap between art and life." Not to mention the gap between the sheets.

Johns had a special enthusiasm for the whole image, for simple solutions, and for accepting the world as it was. He painted commonplace objects or signs, things the mind already knows, such as books, numbers, flags, and targets. Johns recreated rather than represented the simple iconic shapes of these things. He focussed on whole entities or schemes, in which the individual object

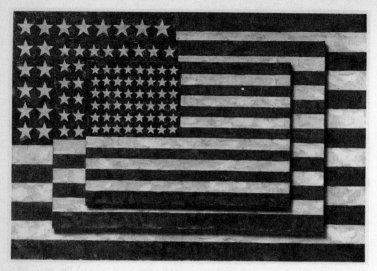

13.1 *What you see is what you get. Jasper Johns's painting* Three Flags *(1958) is just that and nothing more.*

or system would proscribe the shape of the work. In his *Three Flags* (see fig. 13.1), Johns painted the American flag in encaustic (wax mixed with paint) on canvas; the three canvases were then bolted together to make a little pyramid. The shape, color, and design of the flag are taken by Johns as given. His project is to give that familiar form a new context and a new meaning. It is neither a picture of a flag nor the flag itself, but an object that questions what a flag means. In other words, you don't burn it, but you don't salute it either. It is a good example of the way Johns preferred to remake man-made objects. He said, "Take an object, do something to it, do something else to it." And he did. He later made a sculpture of two beer cans in bronze, one empty, one full.

Despite the cultural innovations of Johns and Rausch-
enburg, most art historians agree that Pop art really orig-
inated in swinging England in the period from 1953 to
1956. After the war, the English were suffering serious
shopping deprivation; there was nothing on the shelves,
and not even any glitzy ads. It was a bleak time. That
made American advertising, wide-screen movies, sci-fi,
comic strips, and canned goods look all the more tempt-
ing. A crowd of London artists and intellectuals called
the Independent Group met monthly at the Institute of
Contemporary Art to discuss and analyze these new cul-
tural phenomena. For the Brits, America's cultural and
commercial icons signaled a utopia of fantasy representa-
tions as well as objects of desire. This short-lived move-
ment included Richard Hamilton, Edurado Paolozzi,
Peter Blake, and David Hockney. In 1956, their work
culminated in the futuristically titled exhibition "This is
Tomorrow," which included a billboard of Marilyn Mon-
roe and a live appearance by Hollywood motion picture
star Robby the Robot.

THE WORLD GOES POP:
WARHOL AND LICHTENSTEIN

No artist is more associated with Pop art than Andy
Warhol, the maestro of the Campbell's soup can, but for
him painting was a second career. The son of Polish
immigrants, Warhol studied commercial design at the
Carnegie Institute of Technology in Pittsburgh. He just
wanted a job; something practical. After graduating in
1949, he headed to New York City to pursue a career as
a Madison Avenue advertising artist. He was amazingly
successful and won many awards, including one for a

cookbook designed by his mother. No kidding; the award certificate said "To Andy Warhol's Mother." But he was bored.

Around 1960, the 32-year-old Warhol began to make paintings of ordinary consumer objects, such as Coke bottles and telephones. These looked more like commercial draftsmanship than design, but still incorporated remnants of the drippy Ab Ex style. Some of his friends said, "Lose the drips." So he did. He began to paint his works with an illustrator's precision and absolute indifference. He often selected his subject matter from advertisements. Works like *100 Cans* (1962) (see fig. 13.2) involve serial imagery, the same motif—a Coke can—repeated over and over. Warhol once said, "I want to be a machine." At his studio, the Factory, Warhol made no secret of the fact that he did not paint his paintings himself: he had a staff to do that. These soup cans were handpainted, but later images were silkscreened; Warhol had no interest in connoisseurship or composition or brushwork. He was equally indifferent about his films from the 1960s; they document the everyday events described by their titles: *Eat, Sleep, Blowjob,* and *Haircut.*

Andy (everyone called him Andy) had a rough life. He started losing his hair early, so he always had to wear a really bad white fright wig. Then, in 1968, he was shot and nearly killed by a disgruntled employee who was also president of SCUM, the Society for Cutting Up Men. Finally, he died mysteriously in a New York hospital in 1987 following a routine gall bladder operation. Now he has his own museum in Pittsburgh.

Nothing could be more Pop than the comic strip. The great Pop cartoonist is Roy Lichtenstein, whose paintings

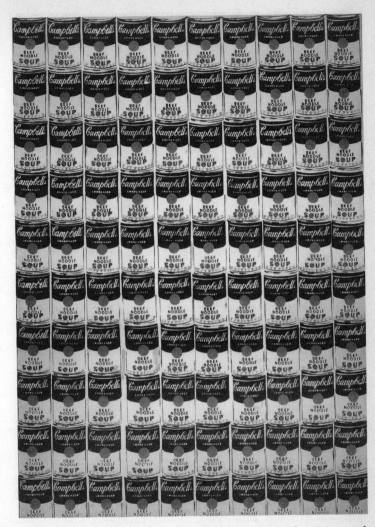

13.2 *The essence of Pop art was to make the banal monumental. Probably the most famous Pop art icons were Andy Warhol's paintings of Campbell's soup cans, such as* 100 Cans *(1962).*

POP PINCHHITTERS

The widely varied Pop art movement involved an unusually high number of eccentrics and wacky characters. These included:

Claes Oldenburg (1929–).
He made giant hamburgers and soft telephones, collected raygun-shaped objects, and opened a store where he sold his own plaster consumer goods at cut-rate prices.

Jim Dine (1935–).
Used real objects such as ties, hammers, lawn mowers, and sinks, against painterly canvases. Also known for the "happenings" he performed and directed.

James Rosenquist (1933–).
A former billboard painter who decided he could make more money painting them on canvas. And he wouldn't have to work on those high scaffoldings. His large works are made up of odd details from ads.

Ed Ruscha (1937–).
He had two themes: paintings of Pop buildings, such as gas stations, and paintings of single words, like *jelly* and *dimple*. He also made a book of photographs of every building on Sunset Strip.

Tom Wesselman (1931–).
His "Great American Nude" assemblages depict pinup girls in bland interiors; they differ from other Pop work in their explicit, if tame, erotic content.

are derived from the colors, techniques, and subject matter of the comics. He sounds like a one-trick pony, but he's mined that genre for three decades with no sign of letting up. Like Warhol, Lichtenstein was trained as a commercial artist; he later taught art for years. His first

13.3 *Roy Lichtenstein has made a career out of copying images from old comic books. In his* Drowning Girl *(1963), he makes the very superficiality of the scene seem poignant and sad.*

one-person exhibition was at Leo Castelli gallery in 1962. He shocked traditional art audiences by showing paintings derived from comic books, commercial advertising, and bubble-gum wrappers. He did not make fun of these images but presented them with a kind of reverence for their simplicity and charming inelegance. Typical is a work like *Drowning Girl* (1963) (see fig. 13.3), selected from a comic-book panel and showing a moment of typi-

cal, stereotyped emotion. The highly abstracted image is reduced to a few primary colors and is built up through clearly delineated outlines and shading made up of hundreds of tiny dots. These dots, called Benday dots (named for American printer Benjamin Day), appear in all printed images but are usually so small they are invisible to the naked eye.

MINIMALISM AND CONCEPTUALISM

Minimalism is best known for its exploration of the cube. Look at an exhibition of Minimalist art and you will see boxes everywhere. But, in fact, there is more to it than that. Minimalism began with a painter, Frank Stella, who had his first retrospective at the Museum of Modern Art in 1960 at the age of twenty-four. Stella rejected the flashy colors and heavy brush strokes of Abstract Expressionism. And he rejected the trashy subjects of Pop art.

Stella's paintings were all stripes, like the pinstripes on a banker's suit. The direction of the stripes was determined, as with John's flags, by the shape of the canvas itself. Generally the canvases were rectangular, but later Stella made paintings with more eccentric shapes. Stella's paintings were so objectlike that they were almost sculptural. So sculptors got interested.

Most of the Minimalist sculptors were former painters themselves. Artists like Robert Morris, Carl Andre, Donald Judd, and Dan Flavin wanted to strip art down to its essential components and to integrate the work with the space around it. They also celebrated industrial production and often had commercial factories fabricate their sculptures rather make the works themselves. Morris's

MAKING A LIST AND CHECKING IT TWICE

Minimalism was the art of getting your boxes in a row, and Conceptualism was the art of making ideas literal. Both were about information and listmaking. So here's a list of the main men—and women:

Frank Stella (b. 1936).
Stripes, stripes, and more stripes.

Donald Judd (1928–94).
Boxes, boxes, and more boxes.

Sol LeWitt (b. 1928).
All possible permutations of boxes.

Agnes Martin (b. 1912).
Mystical New Mexico Minimalist covers plain mono-chrome canvases with faint pencil grids.

Robert Morris (b. 1931).
Boxes covered with mirrors, plus giant sculptures of draped felt and fingerpainted drawings made while blindfolded.

Carl Andre (b. 1935).
Flat squares of metal arranged in grids on the floor. If it's art, step on it.

Eva Hesse (1936–70).
Soft sculpture made of knotted rope, dangling cords and cloth coated with latex or plastic.

Hanne Darboven (b. 1941).
Write, write, write. German Conceptualist produces page after page of neatly scrawled numbers and cursive squiggles.

Joseph Kosuth (b. 1945).
The dictionary is his palette. He exhibits dictionary

MAKING A LIST AND CHECKING IT TWICE
(continued)
. .
definitions of words like "green" and "blue" and
"table" and "chair," sometimes written in neon.

Lawrence Weiner (b. 1941).
The writing was on the wall. Simple phrases, like "over
and under," printed in black block letters directly on
the wall.

large, geometric shapes were fabricated out of grey For-
mica. Andre made "carpets" of industrial metal plates
that he formed into grids on the floor. Judd made boxes
of various dimensions, stacked and grouped in various
combinations. Flavin made environments from store-
bought fluorescent tubes. This work was spare and eco-
nomical. Anyone could make it and anyone could under-
stand it. Stella summed it up when he said, "What you
see is what you see."

If Minimalism stripped art back to its essentials, Con-
ceptual art eliminated the object altogether. Art, said the
Conceptualists, is in the mind. In the protest-oriented
atmosphere of the late 1960s, the notion was regarded
as revolutionary, bound to overthrow the old order of
the art establishment—no art to buy and sell. These art-
ists represented their works (these ideas themselves)
through written statements, diagrams, postcards, photo-
graphs of actions, and artists books. Joseph Kosuth ex-
hibited photostats of dictionary definitions; Lawrence
Weiner printed sentences on the wall; Mel Bochner ex-
hibited numerical sequences; Dan Graham published his
texts as ads in magazines. Art was becoming invisible,
reduced to reading, writing, and arithmetic.

PUBLIC ART

You're walking down the street minding your own business, when suddenly, there it is. Public art. Some giant sculpture in a plaza. Or a mural in a lobby. The stuff is everywhere—parks, airports, train stations, subways, on building facades, in offices, along highways. And it seems that more often than not, public art makes people mad. A few of the great public art controversies of recent years:

Alexander Calder, *La Grande Vitesse* (1969), Grand Rapids, Mich.
Calder's giant red mobile was called an eyesore by Gerald Ford. Today it's a city emblem.

Richard Serra, *Tilted Arc* (1981), New York City.
Antiterrorist experts said the eight-foot-tall, 120-foot-long rusted steel wall at a federal office complex in downtown Manhattan could be used by terrorists to direct the force of a bomb blast toward the building. The work was removed by the government and destroyed in 1989.

Maya Lin, *The Vietnam Veterans Memorial* (1982), Washington, D.C.
The 500-foot-long black granite wall, inscribed with the names of over fifty thousand U.S. war dead, was called a "black gash of shame" by opponents. Now it stands as one of the most moving memorials ever made.

Christo, *Surrounded Islands* (1983), Biscayne Bay, Fla.
Temporarily attaching 200-foot-wide pink plastic "skirts" to eleven small islands was thought by environmentalists to be a danger to aquatic life.

Robert Graham, *Monument to Joe Louis* (1986), Detroit, Mich.
A huge black clenched fist suspended from giant tripod reminded many unhappy viewers of the Black Power salute.

But another wing of the Conceptual artists, equally determined to contest the dainty world of easel paintings in the gallery, were the Earth artists. They made art by digging holes in the desert. One guy made a work called *Mile Long Drawing in the Desert*, which was just that. Another guy made a sculpture out of a huge meteor crater. But perhaps the most famous earthwork was Robert Smithson's *Spiral Jetty* (1970) in the Great Salt Lake. This site-specific sculpture is a spiral road that curves out into the lake and ends. Smithson deliberately referred to ancient Native American effigy mounds, as well as to the natural terrain. He wanted the jetty to interact with the ecosystem of the lake. And it has: it is now submerged.

POSTMODERNISM

The most recent art is called postmodernism, or "po-mo" for short. Postmodernism, as its name implies, challenges some of the most basic ideas of modern art—notions of originality, authorship, and cultural progression, for instance. Many postmodern artists derive their work from advertising photographs, movie stills, and even works by other artists, sometimes literally copying them and calling them their own. What better way to avoid originality than by plagiarizing someone else's work!

Postmodernism looks at the links between pictures of things and our ideas about them. The various po-mo strategies include *appropriation* (taking someone else's image as your own), *deconstruction* (breaking down the meaning of a representation, often by recontextualizing it) and *simulation* (representing as real something that

doesn't exist in the world). All these terms challenge the adage that in a media-saturated world, it's the look that counts.

ARTISTS AFTER THE DEATH OF ART

Postmodern artists and critics always claimed that authorship, the assignment of a name to an original project, was dead. No one could own ideas; all thoughts and images were collective, in constant circulation. Yet we still have individual artists doing stuff. They're not dead. You figure it out, here they are:

Cindy Sherman (b. 1954).
The woman with a thousand faces. For her multiple self-portraits, she poses as everywoman as seen everywhere, from the movies to history paintings.

Jenny Holzer (b. 1950).
Aphorisms and truisms, like "Private Property Created Crime," on posters, stickers, and billboards.

Sherrie Levine (b. 1947).
The premier "appropriation" artist, she copies classic art photos by men photographers to make them her own.

Barbara Kruger (b. 1945).
Her propaganda-style posters directly address the viewer with graphic photo-blowups and phrases like "Your Body is a Battleground."

Jeff Koons (b. 1955).
Der Kitschmeister, celebrates trashy popular culture. His works include vacuum cleaners in clear plastic display boxes, life-size polychromed porcelain statues of Michael Jackson, and huge color photographs of himself and his porn-queen wife making love.

SUMMARY

⏱ Pop took the brash imagery of commercial culture and brought it into the museums.

⏱ Minimalism reduced art to simple shapes that refer only to themselves, not to the emotions of some blow-hard artist.

⏱ Conceptualism took art into the abstract realm of ideas.

⏱ Postmodernism promises a brave new world of self-critical representations.

Page numbers in *italics* refer to illustrations.

CHAPTER 1

1.1 Venus of Willendorf, Austria, c. 30,000–25,000 B.C. Limestone, 4 in. (11.5 cm) tall. Used by permission of the Naturhistorisches Museum, Vienna. 1.2 Cave painting, Lascaux, France, c. 16,000–14,000 B.C. Paint on limestone rock. Used by permission of the Caisse Nationale des Monuments Historiques et des Sites, Paris.

CHAPTER 2

2.1 *Relief of Itwesh*, c. 2475–2345 B.C. Limestone, 16 in. tall. Used by permission of the Brooklyn Museum. 2.2 *Statue of a Kouros*, c. 600–580 B.C. Marble, 72 in. tall. Used by permission of the Metropolitan Museum, New York.

CHAPTER 3

3.1 *The Hour of the Horse*, from "A Sundial of Maidens," Utamaro, c. 1795. Woodblock print. Used by permission of the New York Public Library (no. 108). 3.2 *Stele of a Yogini*, Kannauj, Uttar Pradesh, eleventh century. Sandstone, 86.4 x 43.8 cm. Used by permission of the San Antonio Art Museum, Texas. 3.3 *Kongo Power Figure*, Zaire (1875–1900). Used by permission of the Detroit Institute of Arts Founders Society. 4.4 *Container in the Form of a Diving God*, Maya, c. 1400s. Quintana Roo, Mexico. Clay, 12.7 cm tall. Used by permission of the Princeton University Art Museum.

CHAPTER 4

4.1 Manuscript page from the *Books of Kells*, c. 780. Used by permission of Trinity College, Dublin. 4.2 West Portals, Chartres Cathedral, c. 1145–70.

CHAPTER 5

5.1 Leonardo da Vinci, *Ginevra de' Benci*, 1474. Oil on canvas, 15 x 14 in. Used by permission of The National Gallery, Washington, D.C. 5.2 Raphael, *The Alba Madonna*, 1510–11. Oil on canvas on panel tondo, 37 in. diameter. Used by permission of The National Gallery, Washington, D.C. 5.3 Albrecht Dürer, *Adam and Eve*, 1504. Engraving, 9 x 7 in. Used by permission of the Detroit

Institute. 5.4 Rembrandt van Rijn, *Aristotle Contemplating the Bust of Homer*, 1653. Oil on canvas, 56 x 53 in. Used by permission of the Metropolitan Museum, New York.

CHAPTER 6

6.1 Jean-Honoré Fragonard, *The Love Letter*, c. 1770s. Oil on canvas, 32 x 26 in. Used by permission of the Metropolitan Museum, New York. 6.2 Jacques-Louis David, *The Death of Socrates*, 1787. Oil on canvas, 51 x 77 in. Used by permission of the Metropolitan Museum, New York. 6.3 Eugène Delacroix, *The Lion Hunt*, 1861. Oil on canvas, 30 x 38 in. Used by permission of the Art Institute of Chicago. 6.4 Winslow Homer, *The Gulf Stream*, 1899. Oil on canvas, 28 x 49 in. Used by permission of the Metropolitan Museum, New York.

CHAPTER 7

7.1 Claude Monet, *Waterloo Bridge, London, Sunlight Effect*, 1903. Used by permission of the Carnegie Museum, Pittsburgh. 7.2 Edgar Degas, *Frieze of Dancers*, c. 1883. Oil on canvas. Used by permission of the Cleveland Museum. 7.3 Mary Cassatt, *Susan Comforting the Baby*, c. 1881. Oil on canvas, 25 x 39 in. Used by permission of the Houston Museum of Fine Arts. 7.4 Édouard Manet, *A Bar at the Folies-Bergère*, 1881–82. Used by permission of the Courtauld Institute, University of London.

CHAPTER 8

8.1 Georges Seurat, *A Sunday Afternoon on the Island of La Grande Jatte*, 1884–86. Oil on canvas, 6 ft. 9 in. x 10 ft. 8 in. Used by permission of the Art Institute of Chicago. 8.2 Paul Cézanne, *The Large Bathers*, 1898–1905. Oil on canvas, 82 x 98 in. Used by permission of the Philadelphia Museum. 8.3 Paul Gauguin, *Manao Tupapao (The Spirit of the Dead is Watching)*, 1892. Oil on burlap, 28.5 x 36 in. Used by permission of the Albright-Knox Art Gallery, Buffalo, N.Y. 8.4 Vincent van Gogh, *Starry Night*, 1889. Oil on canvas, 29 x 36 in. Used by permission of the Museum of Modern Art, New York.

CHAPTER 9

9.1 Edvard Munch, *The Sin*, 1901. Lithograph. Used by permission of the Cleveland Museum. 9.2 Henri Rousseau, *The Dream*, 1910. Oil on canvas, 6 ft. 8 in. x 9 ft. 9 in. Used by permission of the Museum of Modern Art, New York. 9.3 Henri Matisse, *Dance I*, 1909. Oil on canvas, 259.7 x 390.1 cm. Used by permission of the Museum of Modern Art, New York. 9.4 Wassily Kandinsky, *Composition 8*, 1923. Used by permission of the Guggenheim Museum, New York.

CHAPTER 10

10.1 Picasso, *Portrait of Daniel-Henry Kahnweiler*, 1910. Oil on canvas, 39⅝ x 28⅝ in. (1.00 x 0.73 m.). Used by permission of the Art Institute of Chicago.

10.2 Picasso, *The Three Musicians*, 1921. Oil on canvas, 6 ft. 7 in. x 7 ft. 3¾ in. Used by permission of the Museum of Modern Art, New York. 10.3 Picasso, *Guitar, Sheet Music and Glass*, 1912. Pasted paper, gouache and charcoal, 18 x 14 in. Used by permission of the McNay Art Museum, San Antonio. 10.4 Piet Mondrian, *Composition*, 1921. Oil on canvas, 29 x 20 in. Used by permission of the Museum of Modern Art, New York.

CHAPTER 11

11.1 Marcel Duchamp, *The Bride Stripped Bare By Her Bachelors, Even*, 1915–23. Mixed mediums on glass, 277 x 176 cm. Used by permission of the Philadelphia Museum of Art. 11.2 Giorgio de Chirico, *The Enigma of a Day*, 1914. Oil on canvas, 73¼ x 55 in. (185.5 x 139.7 cm) Used by permission of the Museum of Modern Art, New York. 11.3 Salvador Dalí, *The Persistence of Memory*, 1931. Oil on canvas, 9½ x 13 in. Used by permission of the Museum of Modern Art, New York.

CHAPTER 12

12.1 Jackson Pollock, *Autumn Rhythm*, 1950. Oil on canvas, 105 x 207 in. Used by permission of the Metropolitan Museum, New York. 12.2 Willem de Kooning, *Woman and Bicycle*, 1952–53. Oil on canvas, 76 x 49 in. Used by permission of the Whitney Museum of American Art, New York.

CHAPTER 13

13.1 Jasper Johns, *Three Flags*, 1958. Encaustic on canvas, 30 x 45 x 5 in. Used by permission of the Whitney Museum of American Art, New York. 13.2 Andy Warhol, *100 Cans*, 1962. Oil on canvas, 72 x 52 in. Used by permission of the Albright-Knox Art Gallery, Buffalo, N.Y. 13.3 Roy Lichtenstein, *Drowning Girl*, 1963. Oil and synthetic polymer paint on canvas, 67 x 66 in. Used by permission of the Museum of Modern Art, New York.